whitegraphics

ROCKPORT

GLOUCESTER MASSACHUSETTS

ROCKPORT

PUBLISHERS

whitegraphics

the power of white in graphic design

gail deibler finke

First published in the United States of America by
Rockport Publishers, Inc.
33 Commercial Street
Gloucester, Massachusetts 01930-5089
Telephone: (978) 282-9590
Facsimile: (978) 283-2742
www.rockpub.com

ISBN 1-56496-724-7

10 9 8 7 6 5 4 3 2

Design: Stoltze Design

Printed in China.

> acknowledgments

Thanks to all the designers whose work is featured here and to the many more whose work makes life more interesting and beautiful for us all. Thanks to my editors at Rockport Publishers, who gave me the opportunity to write about such an interesting and overlooked topic. And, finally, thanks to my family: my husband, Scott, my children, Meghan and Marshal, and my parents and in-laws. Dad, this one is for you.

Gail Deibler Finke has written eleven books and innumerable magazine articles about graphic and environmental graphic design. A former editor at *Identity* magazine and columnist for *HOW* magazine, she works out of her home in Cincinnati.

> contents

> foreword

Of Poems, Cats, and the Color White

This is my eleventh graphic design book, and I must confess that none of my other subjects (entrancing though they were) have moved anyone to poetry. At least, not that I'm aware of. Yet this January, among the piles of envelopes, boxes, tubes, and other parcels brought to my door by trudging couriers, came a unique submission: a poem from designer Robert Qually.

The color white has always intrigued poets. Spenser, writing rapturously of swans, claimed,

> "Two fairer Birds I yet did never see:
> The Snow which doth the top of Pindus strew,
> Did never whiter show,
> Nor Jove himself when he a Swan would be
> For love of Leda, whiter did appear:
> Yet Leda was they say as white as he,
> Yet not so white as these, nor nothing near;
> So purely white they were . . ."

And there's more. Now those were some white swans. In his poem about the Battle of Lake Regillus, Macaulay described a pair of awesome soldiers: "White as snow their armour was: Their steeds were white as snow." Yeats yearned "I would that we were, my beloved, white birds on the foam of the sea!" Elizabethan poet Henry Vaughan lamented the days before life had "taught my soul to fancy aught/But a white, celestial thought." Chesterton dreamed of "White founts falling in the courts of the sun," while, more recently, rock musicians have sung of "nights in white satin," what happens in "a white room with black curtains," and how a face can turn "a whiter shade of pale."

Poets have written of cloth "white as the driven snow" (Shakespeare), "Dusk faces with white silken turbans wreath'd" (Milton), sea spray like "wild white horses" (Arnold), the moon as an "orbed maiden, with white fire laden" (Shelley). Tennyson's Arthurian heroes rejoice that "the world is white with May." As a color, white is a metaphor for many emotions and for concepts ranging from purity to death. And in the poetic images presented above, white plays the same role as it does in the pieces you'll find in this book: contrasting with other colors, providing cool white space, making an emphatic statement. But to my knowledge, no one had—until now—written a poem specifically about white in graphic design. And so I print Qually's to remedy that deficiency.

Then there's the matter of John Sayles' cat. As the first living submission to any of my books, and thoughtfully provided with his own logo, White Space the cat gets a nod here. He's a living reminder that, in graphic design, white is too often thought of as something to cover up or get rid of, not something to explore and celebrate. Sayles rescued a scrawny, unwanted kitten and nursed him until he grew into a sleek, assured animal. Like all cats, White Space goes his own way. Designers would all benefit from occasionally giving the color white free rein and seeing what happens. The projects here show how exciting those results can be.

Gail Deibler Finke
Cincinnati,
April 2000

WHITE "Space"

What is not,
helps us define what is.

What is not,
soon becomes what is.

The what is,
is what was not.

What was left out,
is just as important
as what is put in.

White space
is as real as what fills it.

All acts of creation
start with a blank canvas (white space) . . .
use it wisely.

Another example of this method for creating a positive image with white space is the series of American Design Century books Pentagram recently designed for Potlatch Corporation. Notice how the numbers appear to be on top of the collages when actually there are no numbers at all. The absence of the shape in the photographic collage implies the image of a number.

Some of the most potent design today uses little in the way of imagery or color at all. Take this cover for *Critique* magazine by James Victore, for example. The theme of the issue was "Economy" and Victore's thrifty use of black type on a white field hones us right to the message. There is very little to get in the way of the concept. On the other hand, white on white can be just as effective when used in the right context.

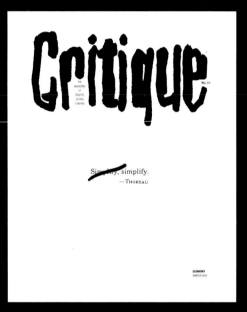

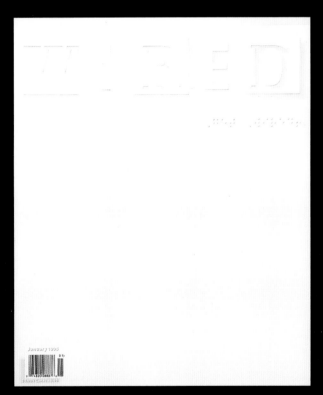

Like the eponymous Beatles double record, also known as *The White Album*, the blind embossed cover for WIRED magazine by designer John Plunkett made the magazine stand out against all the color on magazine newsstands. It screams to be picked up. So does the new Volkswagen Beetle featured in the ad campaign by Arnold Advertising. Remini-scent of the 1960s campaign by Doyle Dane Burnbach for the same automobile, a small "bug" floating on a sea of white compels us as much, or more, than words or multi-layered images could ever do. A nice big chunk of white space is one of the most soothing and comfortable respites from the overloaded hyperactive imagery being created in print and interactive media today. Graphic design has taught me a whole new appreciation for white space. I'm no longer terrified of it the way I used to be in painting class. As a matter of fact, I can now stare right back at it with a lifelong confidence in my ability to deal with it. But, I wonder what St. Peter will say to me when I arrive at the pearly gates? Maybe, "Nice white space, huh?"

Mr. Tharp
Tharp Did It
Los Gatos/San Francisco

The essence of art is creativity. Although the artist may take a "freehand" approach in execution, there are well-defined parameters, which ultimately dictate design. *The creative process is not performed by the skilled hand alone, but must be a unified process in which head, heart, and hand play a simultaneous role.* (Bayer 1979.)

Dentistry lives by both its art and its science. In the past, each community has had one or two practitioners who were considered "true" artists. These clinicians set themselves apart because of what was perceived as unusual talent. Yes, many of these individuals were remarkable; however, it is only with new technologies and a better understanding of the design components that we have begun to realize that a Renoir lives within each of us. This "new age" of aesthetic dentistry is filled with budding artists who can realize enormous potential with greater motivation, guidance and insight.

This year's Symposium is dedicated to those practitioners who are seeking new ways to perfect art in their restorations. Tutelage will come from some of the world's great masters; individuals who truly understand that the Art of Restoration is a melding of head, heart and hand.

Dr. Michael Cohen

Friday

THE INTERNATIONAL MASTERS

Dr. Edward P. Allen
Dr. Peter Wöhrle
Dr. Vincent Kokich
Dr. Robert Frazer, Jr.
Dr. Konrad Meyenberg
Dr. Gerard Chiche
Dr. Pascal Magne
Dr. Daniel Buser
Mr. David Meinz
Dr. Andrew Alpert
Dr. John West
Dr. Stephen Rimer
Dr. Patrick Palacci
Urs Belser
Dr. David Schwab
Dr. Neil Starr

white space

>> Some of the earliest printed books show us that *horror vacui*, or fear of empty space, is nothing new in design. Long before graphic design had a name, typesetters were busy arranging words and pictures on paper. Illuminated manuscripts, produced when every book was hand-written and hand-drawn, are full of generous white margins. Books were so labor-intensive, and took so long to produce, that the pleasing use of white space was practical and economical.

But movable printing changed all that. Paper was comparatively cheap, and while engravings were expensive to produce, they could be used indefinitely. Pictures became a selling point for printers. Where once only the wealthiest could afford pictures in their books, now printed books were crowded with images: full-page pictures, half-page pictures, and borders made up of illustrated shapes piled on top of each other like building blocks.

The craze didn't last long. Saner heads prevailed (and books were even more profitable without illustrations). But unfortunately for the designer, the impetus behind that craze lives on. When you're printing a sheet of paper, it can be hard to justify leaving any of it blank.

Why should you? Well, as any designer knows, *it just looks better*. White space draws attention to whatever it contains. White space provides context, organization, and a restful place for the eyes. It can convey a variety of moods, from a mannered, classic arrangement of type to a dramatic spotlight for a photograph.

White space is the largest chapter in this book for a simple reason: it's one of the most versatile tools a graphic designer can use. Here you'll find white space, not in the generic sense of open space of any kind, but in its literal sense. Open expanses of white. These projects demonstrate the power of white space — enough power, perhaps, to inspire *amor vacui*.

Milliken Carpet Brochure
Copeland Hirthler design + communications

art director > Brad Copeland
designers > Lionel Ferreira, Rebecca D'Attilio
illustrators > Lionel Ferriera, Vivian Mize
photographer > Sandro
copywriter > Rodney Rogers
client > Milliken Carpets
client's business > Commercial Carpet
printer > Seven
paper > Utopia One
colors > Four-color process
printing > Offset
size > 8 ½" x 11" (22 cm x 28 cm)

>> The client, which prints custom patterns on its carpet tile, wanted to market to architects and designers. The high-end, "designer" look of this piece hits that audience. Elegant, full-bleed black and white photography is faced by white pages artfully dotted with images and copy.

The key design element is a white square knocked out of each full-page photo. Only three small numbers indicating the carpet's innovative size—a square yard—interrupt the blank space. Two squares on the white page opposite reproduce the missing image and offer a carpet block based on its design.

White vellum paper covers the carpet brochure. Its elegant texture, the intriguing photo it both hides and reveals, and the simple type treatment all appeal to the brochure's audience: designers and architects.

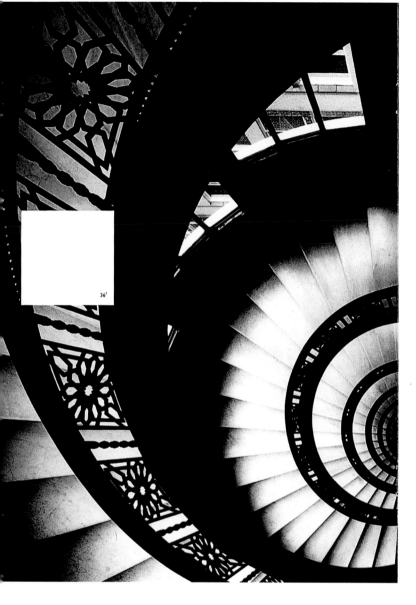

What inspires you? Art? Architecture? A cascading spiral of symmetry and grace? Imagine a vast canvas that beautifully captures the magic of your unfolding vision. A grand stage from which to establish an identity. Reflect a philosophy. Or express an idea.

Inside, provocative full-bleed photographs face nearly blank white pages. White squares knocked out of the photos symbolize the featured product, custom-printed squares of carpet. The missing design square appears on the white page, along with a carpet tile inspired by it. The sophisticated use of white space produces an upscale look far different from typical trade ads and brochures.

Design Within Reach Catalog and Web Site
Pentagram Design, Inc.

art director > Kit Hinrichs
designer > David Asavi
photographer > Stefano Massei
client > Design Within Reach
client's business > Designer furniture
printer > R. R. Donnelly
paper > Memo 60# and 100# Northcoat
colors > Four-color process
printing > Offset
size > 9" x 10 ¾" (23 cm x 27 cm)

>> Whether customers like to shop for furniture online or by thumbing through a traditional catalog, they get the same design experience when buying from Design Within Reach. A mail-order company specializing in furniture by designers, DWR wanted ordering its products to be as design-intensive an experience as using them.

Both catalogues use white space to present the furniture. Each piece is displayed like a work of art in a discrete white box. Photographs of the designers, diagrams of the products, and blocks presenting colors and finishes are stacked together in this Mondrian-inspired layout.

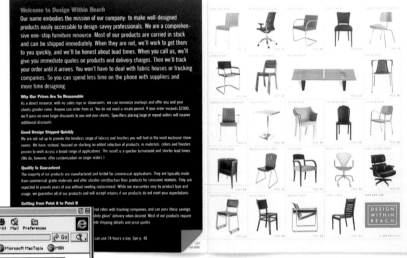

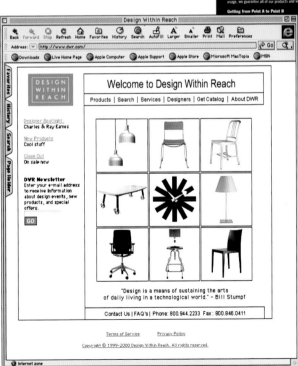

Unlike many web sites, which run riot with color and clog up computers with complicated background images, this site greets users with a clear white background that showcases small product shots. Grid lines break up the white space and create a high-end, "designer" look appropriate to the expensive product.

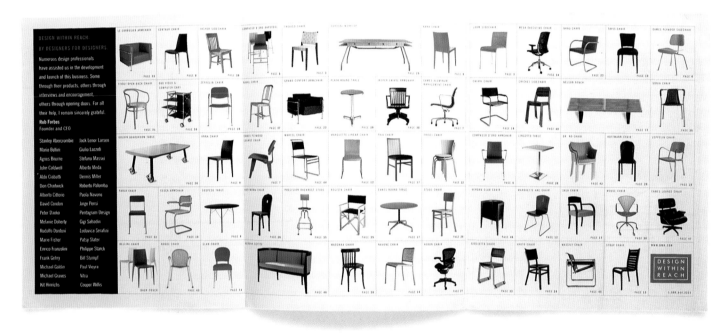

Product shots, designer photographs, descriptions, diagrams—all are contained and displayed in white boxes divided by hairline rules. The clean use of space and orderly grid are both hallmarks of the modern style the furniture embodies.

Like the web site, the print catalog begins with a grid of white squares, each holding the image of one chair (tables take two squares). White squares of various sizes contain the images and text throughout the book.

EAMES PLYWOOD SIDECHAIR ▼

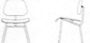

	Ebony	Natural

Designers: Charles and Ray Eames

H 29.5" **D** 20.5" **W** 20.5" **Materials:** 5-ply plywood; chromed-steel legs and back brace, rubber shock mounts and nylon glides.

Charles and Ray Eames' work has been a major influence for half a century, and that influence keeps on growing. Their keen interest in molding plywood led first to a Navy commission to produce plywood stretchers and splints. In 1946, they brilliantly applied that technology to the design of their DCM dining chair by Herman Miller. While an exceedingly elegant work, it's also a model of economy—a thin steel frame supports a seat and back composed of two molded plywood shells. Its thrifty use of materials and rational design quickly made it an icon of postwar American modernism.

Ebony Sidechair: AA0107 List $420 / **DWR $325**

Natural Sidechair: AA0013 List $385 / **DWR $295**

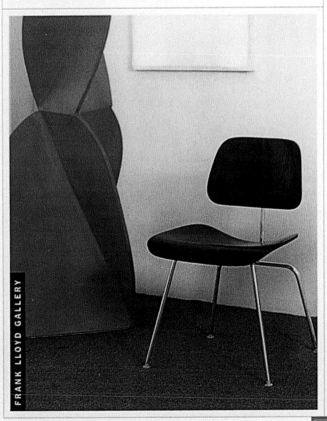

FRANK LLOYD GALLERY

No collection of modern furniture is complete without a piece from Charles and Ray Eames.

1.800.944.2233 1.800.846.0411 Fax

▼ EAMES PLYWOOD LOUNGE CHAIR

H 26.5" D 24.5" W 22"	Ebony		███
Natural		Red	███

Designers: Charles and Ray Eames

Materials: Ash veneer and maple plywood; 5-ply seat and back, 8-ply legs and lumbar support; rubber shock mounts.

The Eames plywood lounge chair is as classic a piece of modern furniture as exists. Formal enough for the finest lobbies, casual enough for residential use—a timeless design piece.

Ebony Lounge Chair: AA0014 List $715 / **DWR $580**

Natural or Red Lounge Chair: AA0115 List $675 / **DWR $540**

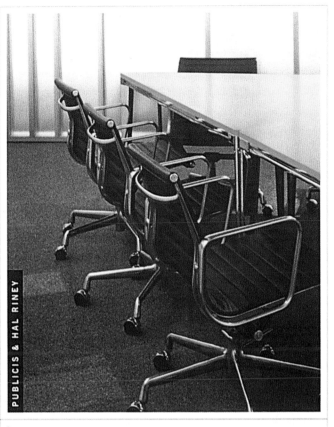

PUBLICIS & HAL RINEY

For an expanded selection of Eames products, visit our website at

W W W. D W R .C O M

EAMES ALUMINUM MANAGEMENT CHAIR ▲

H 33-34" D 17" W 23"	Black ███
Designer: Charles and Ray Eames	

Materials: 5-star aluminum base and frame with tubular-steel column; leather seat and back.

Bobby Fischer wouldn't play chess unless he was sitting in this chair. At the World Championship in Reykjavik, he refused to begin his match with Boris Spassky without one. When he saw the chair, Spassky became convinced that Fischer had an unfair advantage, and he then refused to play until he got one too. All this might seem like much ado about a chair, if it weren't the Eames Management Chair. With its ample proportions, deep cushions, padded arms and clean-cut good looks, it's possibly the most influential executive chair ever designed. It certainly is one of the best selling. Designed to accommodate the individual, its seat tilts and swivels, and its height can be adjusted.

Eames Aluminum Management Chair: AA0042 List $1460 / **DWR $1175**

19

white space

Tejon Ranch 1998 Annual Report
Douglas Oliver Design

art director > Doug Oliver
designers > Doug Oliver, Jennifer Spencer
photographers > Bill Livingston, Aiden Bradley
copywriter > Delphine Hirasuna
client > Tejon Ranch
client's business > Real estate development
printer > Applied Graphics
paper > Mead Confetti, Mead Signature
colors > 8/8
printing > Offset
size > 8 ½" x 14" (22 cm x 36 cm)
print run > 2,000

>> To communicate the long-term value of a stable stock, this annual report for a real estate developer relies on white space, both literal and figurative, to create a sophisticated look. The company develops a small strip of land adjoining a real, working ranch, which is its greatest draw and most important asset. The report assures investors about both the development's growth and the continued success of the ranch.

A French-folded white confetti paper cover depends on unprinted space for its graphic impact. Inside, text and financials are printed on beige confetti paper. The light brown color adds to the handmade feel of the piece and contrasts with its central section, a series of fine black and white photographs of the cowboys at work, printed on crisp white-coated paper.

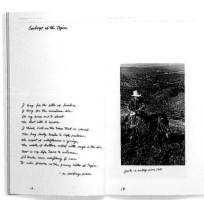

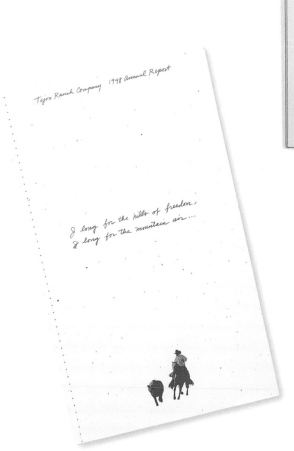

The annual report's cover design gets its impact from the white flecked paper. A small image with the look of screenprinted art, handwritten copy, and saddle stitching decorating the perfect binding set the stage for the copy and photographs within.

A cowboy poem starts off the center section, featuring black and white photographs of cowboys at work on the ranch. White space defines and contains the photos, which also showcase the ranch itself.

Flora 1997 Calendar
Belyea

art director > Patricia Belyea
designer > Ann Buckley
illustrator > Ann Buckley
photographer > Rosanne Olson
client > Rosanne Olson/
Belyea Design Alliance;
The Allied Printers/
Strathmore Paper Co.
printer > The Allied Printers
paper > Strathmore Renewal
colors > Four-color process
plus eight spot inks
printing > Offset
size > 16 ½" x 8 ½" (42 cm x 22 cm)
print run > 3,000

>> A self-promotion piece for four creative companies (a designer, a photographer, a printer, and a paper mill), this calendar features unusual binding and dreamlike imagery. The photographs range from still lifes to portraits, but all feature flowers. The long, narrow shape recalls boxed flowers and makes the piece distinctive from the first. The mossy green paper, printed with the word *Flora* in white ink, hints at a botanical theme.

The inside layout, mostly white space, showcases both the paper stock and the photographer's work. Restful and romantic, the calendar invites users to a quiet reverie in the midst of their busy day.

The designer chose the paper color, "fern," to complement the floral imagery. The title and date appear in glossy white raised ink.

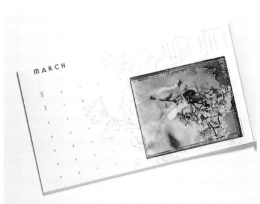

Expanses of white paper showcase the photographer's dreamy images, which seem to float languidly on the surface.

Artfully placed type and faint lines make an elegant flow chart advertising the printer.

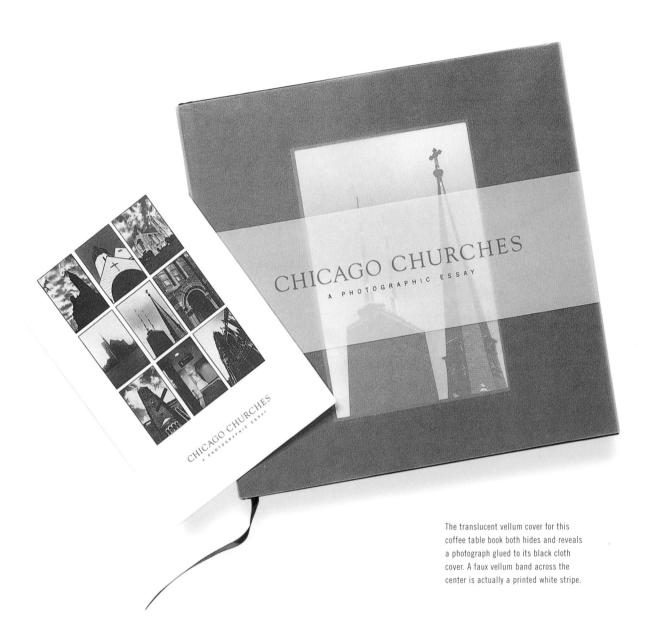

The translucent vellum cover for this
coffee table book both hides and reveals
a photograph glued to its black cloth
cover. A faux vellum band across the
center is actually a printed white stripe.

art director > Elizabeth Johnson
designer > Elizabeth Johnson
photographer > Elizabeth Johnson
printer > Palace Press International
paper > 180 gsm Woodfree
colors > Three
printing > Offset
size > 11" x 11" (28 cm x 28 cm)
print run > 10,000

>> A translucent white vellum slipcover gives a luxurious feel to this coffee table book by a new publisher. Designer Elizabeth Johnson, who owns Uppercase Books and took all the photographs, wanted to give her first book a subtle, sophisticated design.

The slipcover sets the mood. A stripe of white ink beneath the title gives the look of a second vellum wrap without the expense. The slipcover also reveals one of the book's distinctive photographs, glued to an embossed rectangle on the book's black fabric cover. Inside, black and white photographs float serenely in white space, one to a page. Photos are reproduced as tritones, with metallic copper ink creating a distinctive, otherworldly feel.

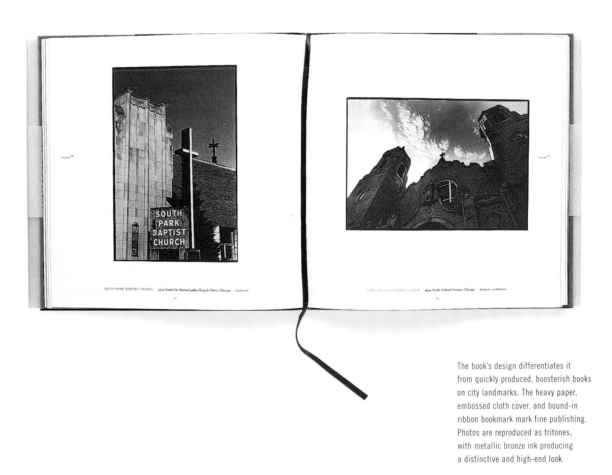

The book's design differentiates it from quickly produced, boosterish books on city landmarks. The heavy paper, embossed cloth cover, and bound-in ribbon bookmark mark fine publishing. Photos are reproduced as tritones, with metallic bronze ink producing a distinctive and high-end look.

Die Schneekönigin
Buero fuer Gestaltung

art directors > Christoph Burkardt, Albrecht Hotz
designers > Christoph Burkardt, Albrecht Hotz
illustrator > Martin Glomm
client > Self
printer > Druckerei Lembeck
colors > Seven
printing > Offset
size > 11" x 12" (28 cm x 30 cm)
print run > 2,000

>> This self-promotional piece, Hans Christian Andersen's fairy tale "The Snow Queen," bears little resemblance to a children's book. Instead, it recalls many early-twentieth-century custom books with its bright colors, modernist illustrations, and heavy textured paper.

Like most of Andersen's work, this fairy tale has dark, adult undertones. It concerns two playmates, a boy who is taken away by the mysterious Snow Queen and a girl who rescues him from her icy palace. This version of the story is all adult in design. Nontraditional type layout and abstract illustrations give little hint to the story. The designers' only concession to obvious symbolism was choosing a bright white paper that represents snow.

Like many classic custom books, this version of "The Snow Queen" features luxurious, heavy paper and innovative binding. It's so beautifully made that it is as likely to appeal to a book collector as to a potential client.

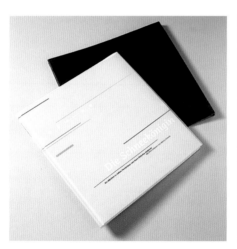

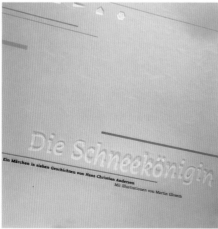

A black slipcover hides the white self-promotional book, Hans Christian Andersen's "The Snow Queen." The title is ghosted out of the transparent plastic jacket, printed in light gray, to reveal the white fiberboard binding beneath.

Provocative, modernist illustrations, nontraditional type layout, and profuse white space give the fairy tale's text an adult presentation. Profuse white space acts as a significant design element and symbolizes snow.

White space acts as a second color in the inside front and back cover designs, showing snow falling on the countryside. In the story, the evil Snow Queen appears to wreak havoc when the snow falls. Here the falling snow reveals the thick white paper beneath it and creates a quiet, folk-art look.

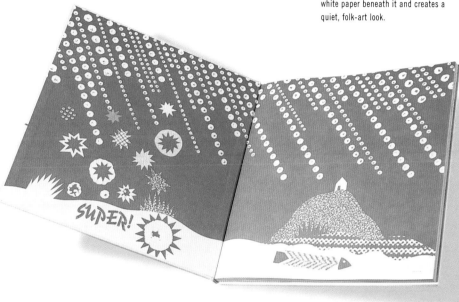

creative director > Steve Liska,
Liska and Associates Chicago

designer > Susanna Barrett,
Liska and Associates New York

copywriters > Richard Grefé, Roz Goldfarb,
Jessica Goldfarb

photographer > Frederik Lieberath

client > American Institute for
Graphic Arts

paper > Mohawk Supreme Ultrawhite
Eggshell Cover

colors > Two

printing > Offset

size > 8 ½" x 5 ½" (22 cm x 14 cm)

print run > 3,500

>> As annual reports continually prove, financial information doesn't have to look dull. This book, the results of a salary survey of graphic designers, managed to present financial information (from charts to texts explaining the professional practices endorsed by the American Institute for Graphic Arts) in a readable way.

Designers made the most of a low budget by creating a striking black and white piece. Instead of using a second color, they specified a second hit of black to produce more contrast between the black and white pages and greater depth in the photographs of unusual currencies from cultures that do not use bills and coins.

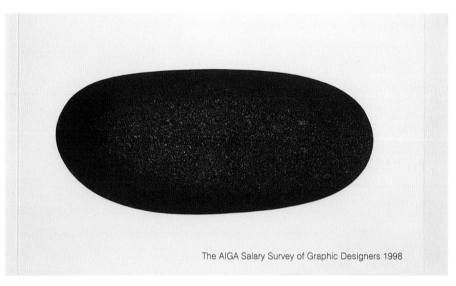

The AIGA Salary Survey of Graphic Designers 1998

The cover image is a Je stone, used for money in Irian Jaya. A double hit of black makes the image seem three-dimensional against the smooth, bright white paper.

Cast money. Copper or brass manilla. West Africa. 15th to mid-20th century. Main currency of West Africa, used for most commercial transactions until 1948. Value confirmed by ringing quality of cast manillas. 2 1/2" x 3 1/4"

Promotions, Titles, Salary, and Profit Sharing Of all possible employee incentives, the award of increased earnings and position within a company is most powerfully associated with retention. How this is done is complex and dependent upon the relationships between staff and other variables within an organization. The following is a partial listing of issues that must be addressed by the firm when structuring these policies:

>Existing organizational structure: Is there a system of grade levels and titles? The premise is that a system of grade levels and titles is necessary and has to be defined. In larger organizations, titles, job descriptions and salary ranges are often tied to a point gradation system. While smaller design firms may be able to use a simpler plan, they should still correspond titles to a salary range.

>Deciding when to award a promotion: Has any time frame or length of service been deemed necessary to attain a promotion? Have accomplishments been defined to justify a promotion such as excellence in performance or advanced education? Who should be moved up through this system and when? The answers to these three questions involve some subjective judgment, but should be related to objective criteria developed in a personnel policy manual and through prior discussion of expectations with the employee. They also depend on the quality of communication established between the employer and employee, especially during scheduled and ad hoc employee review sessions. While most businesses give experience primary weight, performance or talent can supersede issues of longevity in creatively driven businesses. The inherent danger in promoting a junior over a senior person is the possibility of friction and the implied message to the senior members that it may be time to seek another position.

>Maintaining parity with other staff members: Has basic equality of salary, title and relationship to the length of term of employment been considered? A rule of thumb is that there are no secrets in organizations, so the importance of parity cannot be overemphasized. Parity is an issue pegged to the necessity of an established structure to link titles to salary ranges. Each new hire by a firm offers the opportunity to review the existing salary structure to see if it is current with the marketplace.

>Establishing a financial cap to a defined position: It is recommended that a cap on a salary range for a specific title be established. If the employee is with the firm long enough to outlive the nominal increases allowed for the position and cannot be promoted, the employer should consider the other alternative compensations outlined under Employee Retention.

A photo of copper money once used in West Africa seems too large to fit on the page. Placed opposite the uncluttered white space, an explanation of certain professional practices endorsed by the AIGA seems less dense.

Hess House Concert Invitation
Philip Fass

art director >	Philip Fass
designer >	Philip Fass
copywriters >	Harvey Hess, Philip Fass
client >	Harvey Hess
printer >	Karen's Print Rite
paper >	Neenah Ultra Heavy, tracing paper, slide label
colors >	One
printing >	Offset
size >	5" x 5" (13 cm x 13 cm)
print run >	300

>> Each year the designer creates an invitation for an annual house concert. His challenge is to interpret music through graphics that can be produced cheaply by a local quick-printer. This solution, small white sheets of vellum papers covered with mathematically precise drawings, makes a fine keepsake for recipients used to more mundane fare. The translucent white paper lets readers look through each sheet to the next, making a design that changes as each sheet is taken away.

The package is wrapped in white tissue paper and sealed with a printed white slide label. "With just the type on the slide label, anyone invited to the event could find the way," says the designer. "But through viewing the cards one can have another sort of experience, one that I hope builds positive anticipation."

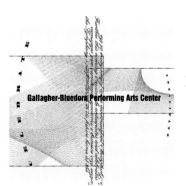

A printed slide label seals the invitation's tissue paper wrapping. The all-white presentation keeps the design a secret until the last moment.

MAESTRO
John Lo Piccolo

newly-appointed Music Director/Conductor

(((((((((((((((((((((((((((((((of the)))))))))))))))))))))))))))))))))))))))

W A T E R L O O C E D A R F A L L S

Symphony Orchestra

t o h o n o r

THIS CONCERT-RECEPTION IS ON

Attire is Casual.

WEDNESDAY, THE **7th** OF OCTOBER AT **7** O'CLOCK

Seating is non-linear.

The performance will begin at the sound of the fanfare.

505 FREDERIC AVENUE, WATERLOO.

The audience is encouraged to enjoy the gardens
by Roger Bartlett.

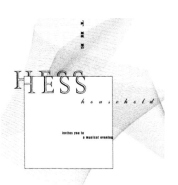

The designer planned carefully so that the two-sided images needed for each invitation would print out correctly on two letter-size sheets of paper. "The press operator did an outstanding job," the designer says, "given that she was running a nonbearing press," which makes it more difficult to control the impression.

Corus Entertainment Letterhead
The Riordon Design Group

art directors >	Ric Riordon, Dan Wheaton
designer >	Sharon Pece
illustrator >	Sharon Pece
client >	Corus Entertainment
client's business >	Media
printer >	Contact Creative Services
paper >	Supreme
colors >	5/3
printing >	Offset
size >	9" x 12" (23 cm x 30 cm) (folder)
print run >	5,000

>> White paper showcases the client's multicolored corporate logo in this letterhead package. A die-cut folder, varnished in a dot pattern to add texture without adding more color, sets the stage. Inside, bright colors set off the crisp white letterhead paper and communicate that the company takes fun seriously.

Inside, the custom folder is printed green and orange and die cut to showcase the white letterhead and business card. A dot pattern printed on the orange and narrow gray lines on the stationery pieces continues the textured look.

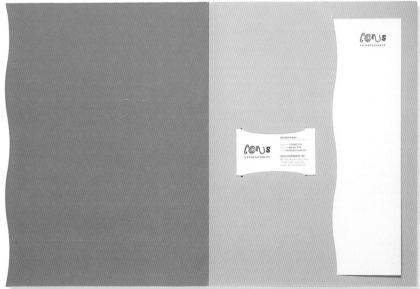

The multicolored logo leaps off the glossy white cover of this folder, die-cut in a wave to reveal the green pocket beneath it. A dot pattern in matte varnish adds more texture.

Christmas Card
Vestígio

art director > Emanuel Barbosa
designer > Emanuel Barbosa
client > Self
printer > Greca-Artes Gráficas
paper > Neptuno
colors > One
printing > Offset
size > 8" x 4" (20 cm x 10 cm)

>> Rather than printing a four-color piece, the designers chose to let an unusual image and the natural beauty of a heavy, textured paper stock convey their wishes for a serene, peaceful Christmas. The resulting card, simple and tranquil, stood out from typical bright holiday greetings.

Feliz Natal e Bom Ano Novo
Merry Christmas and a Happy New Year

Thick white paper represents the thick white snow in the image. Together the illustration and type take up only half the space, leaving the other half empty to convey a wish for peace and tranquility.

Vestígio:

Vestígio: *Consultores de Design, Lda.*
R. Chaby Pinheiro, 191 - 2º
P-4460-278 S. da Hora, Portugal

Tel. +351. 22. 9542461 Fax +351. 22. 9542461
info@vestigio.com

A custom die cut in the shape of Thomas Jefferson's head and large expanses of white space surrounding the type create an unusual poster design. A pop-up feature and the deliberate use of creases create an arresting portrait that is both graphic and sculptural. Simple, classic type floats in the negative space, inviting the viewer closer.

art director > Keith Godard
designer > Keith Godard
asst. designers > Sue Oh, Maria Müller
client > University of Virginia
School of Architecture
printer > CRW Graphics
paper > Monadnock Astrobrite
65 lb. cover
colors > One
printing > Offset
size > 24 ¹/₂" x 36 ¹/₂" (62 cm x 93 cm)
print run > 2,000

>> A distinctive custom die-cut and provocative illustration portray Thomas Jefferson in this poster for a series of architecture lectures. The series, which fit Jefferson's ideal of the free sharing of ideas, was held on the college campus he himself designed, so communicating his legacy was a design goal.

The poster's shape and the engraving-inspired illustration of the eye hint at the architect-president's personality and philosophy. Because the poster had to be folded to be mailed, the designers arranged the type to work with the necessary folds and built in a pop-up effect for Jefferson's head. "We wanted the sculptural effect of folding drawing paper, and the play of light and shadow" appropriate to the architectural subject, the designers explain. The large expanses of white space make the type readable while emphasizing the poster's sculptural effects.

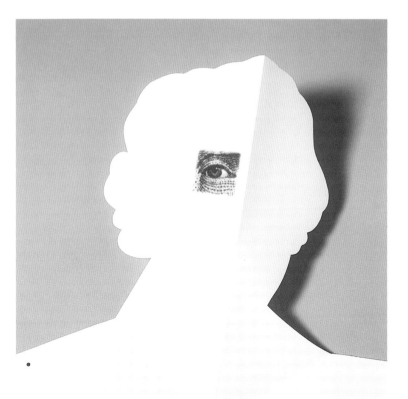

Los Viente del Siglo Viente CD Collection
Estudio Pérez Medina

art director > David Pérez Medina
designers > David Pérez Medina, Oscar Saez,
Carlos Jimeno
photographers > Various
client > EMI
client's business > Music
colors > Four-color process (booklet);
two (label)
printing > Offset, screenprinting

>> This twenty-CD collection needed one design to tie the series together. "White is the base of the collection," the art director explains. "All the other colors work as distinguishing elements for each title."

Printed in Nederland for retail in Spain, the mid-price CDs needed to be produced easily and economically. To eliminate problems matching the colors on the booklets (printed in CMYK) to the CDs (screenprinted), designers kept the logo in black and white.

Each of the twenty CDs, covering musical styles ranging from acid jazz to flamenco, has its own color. The covers, mostly white, create a strong and easily recognized brand.

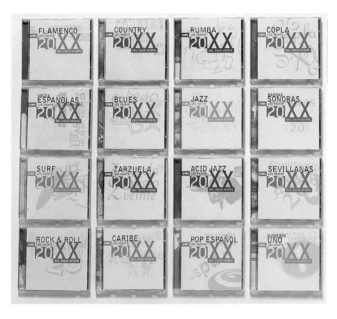

While the CD covers are mostly white, the rest of the printing is in the CD's signature color. To avoid problems matching the CMYK colors, all the disks were screenprinted in black and white.

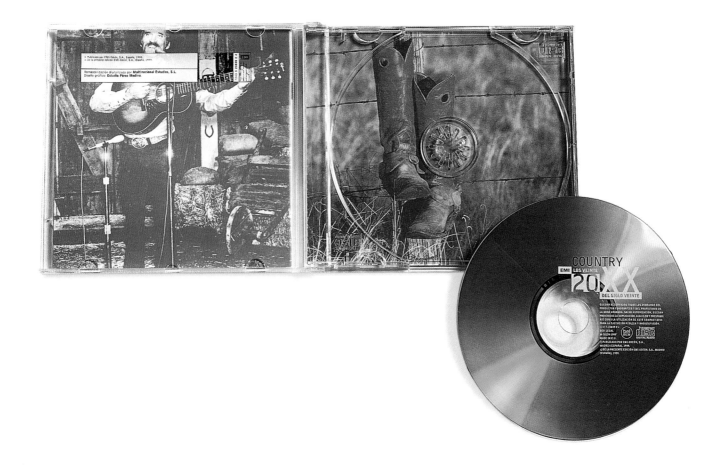

中国民族音乐歌舞晚會

An Evening of Chinese Music and Dance

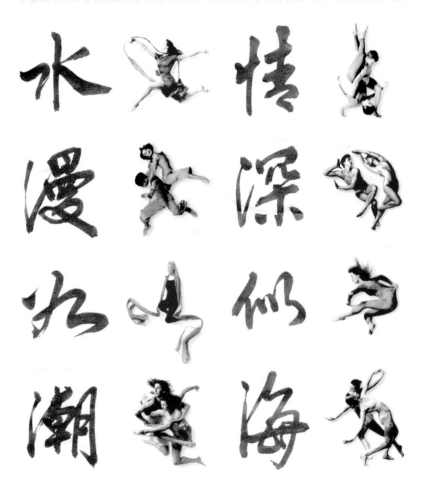

John Hancock Hall · 1998 年 8 月 29 日 (星期六) 8:00 pm · Boston China Art Association

An Evening of Chinese Music and Dance Poster
Arrowstreet Graphic Design

art director > Bob Lowe
designer > Ed Wousek
photographer > Lois Greenfield
calligrapher > C.C. Chen
client > Boston China Arts Association
client's business > Civic organization
paper > HP inkjet photo paper
colors > One
printing > Inkjet
size > 29" x 38" (74 cm x 97 cm)

>> This pro-bono poster advertising a fundraiser to help flood victims in China juxtaposes dynamic photos with Chinese calligraphy. A low-budget piece designed to be printed in house, the poster relies on a clever use of gray scale and revealed white space to create a three-dimensional look.

Faux embossing gives distinction to the event's title and location, which frame the poster at the top and bottom. The white English letters and Chinese characters are created entirely by computer-generated shadows. The calligraphy and photographs, in contrast, pop off the page and appear three-dimensional because of the designer's use of gray scale. A light gray overall pattern, reminiscent of crumpled paper or of marble veins, makes the graphics seem to float. The Chinese text refers to floods coming in waves and to the love of the rescuers being as deep as the sea.

Shadows create the illusion that the English and Chinese informational text is embossed. A faint gray pattern below the photos and Chinese calligraphy makes them appear to float above the paper.

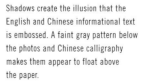

art director > John Sayles
designer > John Sayles
illustrator > John Sayles
copywriter > Annie Meacham
client > Sheree Clark
colors > One

>> To introduce her friends to new cat Sascha B., Sayles Graphic Design principal Sheree Clark hosted a shower. She sent friends and cat-loving clients this whimsical invitation. The low-budget piece, printed on white paper, makes the most of light-hearted copy and humorous illustrations by John Sayles. Abundant white space displays the playful black line drawings, conveying an overall French style to the piece. A dot screen gray adds the look of a watercolor wash and gives the impression of a third color. Besides being economical, the black, white, and gray color scheme matched the cat's silvery fur. "It was a great excuse to throw a party," Clark says. "Sascha knew she was the center of attention!"

A dot screen adds a second "color" to the whimsical black line drawings, looking like a watercolor wash. Abundant white space adds to the airy French feel.

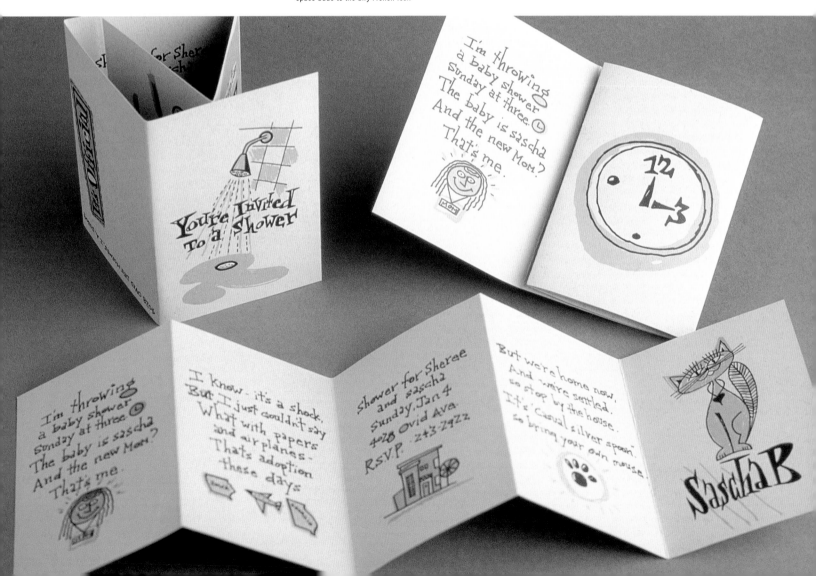

art director > Philip Fass
designer > Philip Fass
copywriter > Justine Picardie
client > Gallery of Art,
University of Northern Iowa
client's business > University art gallery
printer > Karen's Print Rite
paper > Neenah Ultra Heavy
colors > One
printing > Offset
size > 4 ³/₄" x 7 ¹/₂" (12 cm x 19 cm)
print run > 350

>> Inexpensive to produce, this invitation for a university art gallery gets its impact from layered type on vellum paper. White paper makes the all-black graphics and the unusual shape of the piece stand out. The transparent vellum lets readers see from one sheet to the other, creating a message that can be read both all at once and in pieces as the invitation is unfolded. Two weights of paper give the invitation even more tactile quality.

Asymmetrically wrapped in white tissue, the invitation's unusual shape makes the recipient wonder what's inside. Though thin, the tissue hides the transparent piece inside.

Type layered on the heavy vellum card and tissue-thin vellum insert fit together to form a whole. If the tissue falls out, all the essential information is on the card.

Life Weekly Magazine Covers
The *Observer*

art director > Wayne Ford
designer > Wayne Ford
copywriter > Justine Picardie
client > The *Observer*
client's business > Publishing
printer > Quobecor
paper > Newsprint
colors > Four
printing > Offset
size > 11" x 14 ¹/₂" (28 cm x 37 cm)
print run > 420,000

>> Most magazines, regardless of how they're distributed, rely on photography to grab the reader's attention. Even magazines with no retail sales and magazines included in newspapers or other publications usually depend on photography to entice the reader to open them. In striking contrast, type-only covers for *Life*, a weekly magazine for the *Observer* newspaper, make a bold and innovative statement. Bright colors and choice words leave readers guessing, practically daring them to look inside.

No photos for the cover of these *Life* magazines! White space emphasizes the lack of photography and allows the black logo and brightly colored type to make maximum impact.

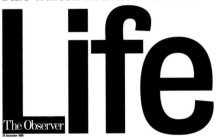

Name Change Announcement
Hornall Anderson Design Works

art director >	Jack Anderson
designers >	Jack Anderson, Heidi Favour, Bruce Branson-Meyer, Mary Hermes
illustrator >	Mahlum Architects
photographer >	Various
calligrapher >	Todd Apjones
client >	Mahlum Architects
paper >	Strathmore Beau Brilliant, Palm Beach White (cards); Thai Chiri (outer wrap)
colors >	Nine
printing >	Offset

>> Rather than send a simple announcement of its name change, the client wanted something spectacular. The result was a set of square cards wrapped in a textured cover and sewn into a transparent vellum envelope.

"Contrasting images are coupled with one-word descriptors and centered on the white cards," say the designers. "The use of white space enabled the recipient to focus on the client's capabilities."

Contrasting images printed in debossed squares and floated in wide frames of white space represent the client's capabilities. The result is a memorable keepsake rather than a simple announcement.

AMF Bowling Worldwide Brochure
Michael Stanard, Inc.

art director > Michael Stanard
designer > Michael Stanard
copywriter > Michael Stanard
client > AMF Bowling Worldwide
client's business > Bowling centers and products
printer > Unique
colors > Six
printing > Offset
size > 8" x 11 ¼" (20 cm x 28.5 cm)
print run > 10,000

>> White is used dynamically throughout this annual report for a company that owns bowling centers and sells bowling products. The all-white cover focuses attention on a soft, three-dimensional illustration that symbolizes the company's name and its global markets. Inside, white is part of a sophisticated set of graphic tools used to position bowling as a growth industry, a fun sport, and a family activity.

Dynamic type and graphics, clever diagrams, vibrant illustrations, and even a foldout section create visual excitement. Throughout the book, white balances the vivid use of color and creates its own excitement.

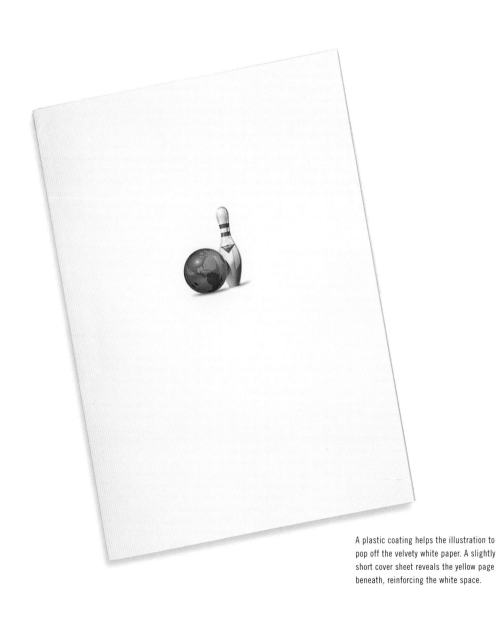

A plastic coating helps the illustration to pop off the velvety white paper. A slightly short cover sheet reveals the yellow page beneath, reinforcing the white space.

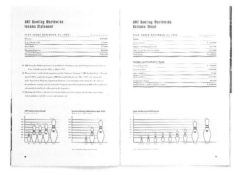

White space showcases the dynamic use of type, ink, and whimsical diagrams on the financial statement pages.

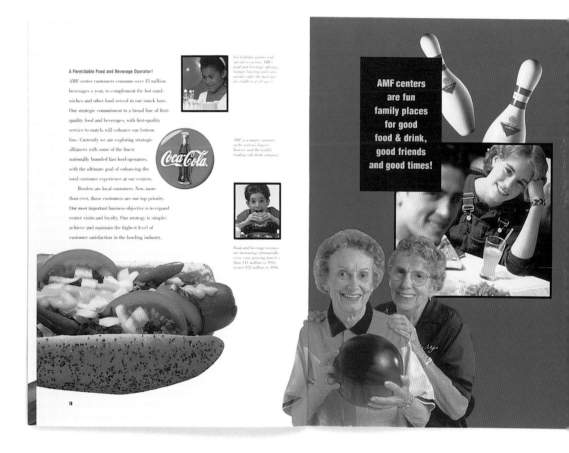

A Formidable Food and Beverage Operator!

AMF center customers consume over 15 million beverages a year, to complement the hot sandwiches and other food served in our snack bars. Our strategic commitment to a broad line of first-quality food and beverages, with first-quality service to match, will enhance our bottom line. Currently we are exploring strategic alliances with some of the finest nationally branded fast food operators, with the ultimate goal of enhancing the total customer experience at our centers.

Bowlers are loyal customers. Now, more than ever, those customers are our top priority. Our most important business objective is to expand center visits and loyalty. Our strategy is simple: achieve and maintain the highest level of customer satisfaction in the bowling industry.

For birthday parties and special occasions, AMF's food and beverage offerings, bumper bowling and video arcades offer the most fun for children of all ages.

AMF is a major customer of the nation's largest brewers and the world's leading soft drink company.

Food and beverage revenues are increasing substantially every year, growing from less than $11 million in 1993, to over $22 million in 1996.

AMF centers are fun family places for good food & drink, good friends and good times!

White pages display photos, graphics and text, and contrast with pages printed in vibrant inks. In effect, the white space becomes another ink color.

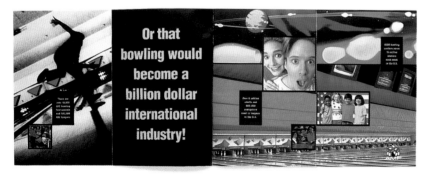

Or that bowling would become a billion dollar international industry!

Inside, full-color pages (including the foldout) create a sense of vibrant excitement. Full bleed photos, brash type, and shots of people around the world, of all ages and races, convey that bowling is a growing sport enjoyed by millions.

art director > Ric Riordon
designer > Greer Hutchison
photographer > David Graham White
copywriter > Shirley Riordon
client > Self
printer > Somerset Graphics
paper > Frostbrite Matte
colors > Four-color process
printing > Stochastic
size > 4" x 6" (10 cm x 15 cm)
print run > 500

>> White space creates a modern, sophisticated look for this design firm's open-house invitation. Generous white margins frame tiny, intensely colored photographs of the designers' new offices. The quintessentially 1990s type treatment features extra space between letters and lines for a further feeling of space.

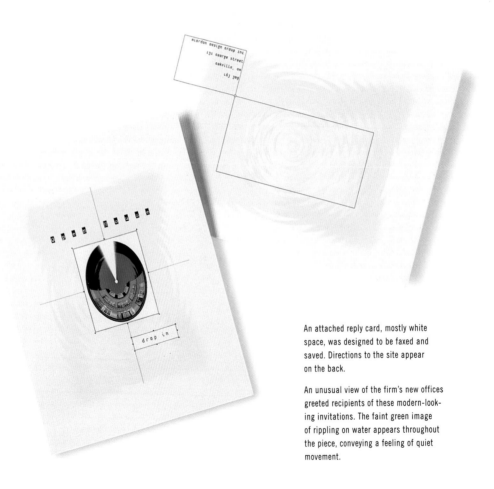

An attached reply card, mostly white space, was designed to be faxed and saved. Directions to the site appear on the back.

An unusual view of the firm's new offices greeted recipients of these modern-looking invitations. The faint green image of rippling on water appears throughout the piece, conveying a feeling of quiet movement.

art director > Richard Puder
designer > Richard Puder
client > Pudley's Pub
client's business > Restaurant
colors > One
printing > Offset or laser
size > 11" x 17" (28 cm x 43 cm)
print run > 5,000 and counting

>> Meant to be colored by the diners, this menu design is a playful variation on the Nantucket Island restaurant's logo, a pig. "Everything is priced at $4.95," says designer Richard Puder, "so that price is the bullet separating menu items."

Because the menus are given away, they need to be produced continually. Puder designed them to fit on a standard sheet so that they could be printed cheaply and easily. In a pinch, they can be run off on a laser printer.

When you're a kid who wants to color, anything but a white background defeats the purpose. Items on the menu are arranged in the shape of a pig, the restaurant's logo. Children can color in their menus while waiting for their food.

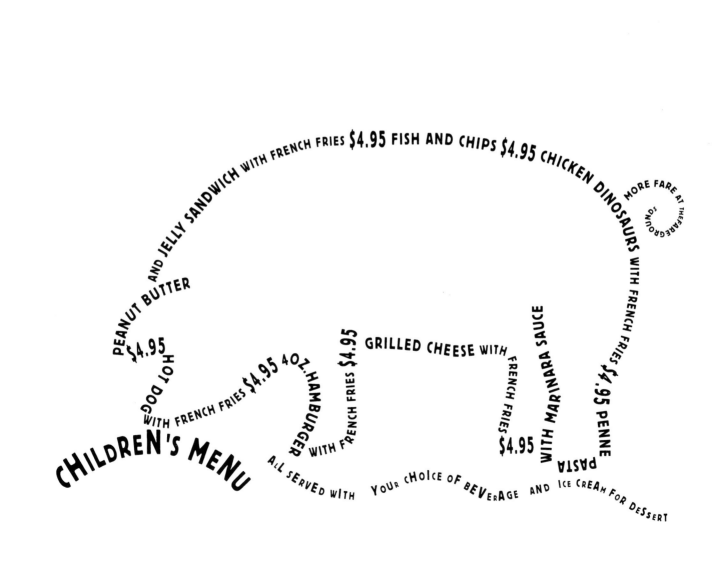

UNI Department of Art Faculty Exhibition Poster
Philip Fass

art director > Philip Fass
designer > Philip Fass
client > Gallery of Art,
University of Northern Iowa
printer > Congdon Printing and Imaging
paper > Fortune Gloss 80#
colors > Two
printing > Offset
size > 12" x 18" (30 cm x 46 cm)
print run > 2,000

>> Without explaining its imagery, this poster presents the idea of an exhibition as an offering, a seed planted by the artist, intended to "grow" new ideas when nurtured by the viewer, represented by the images of water. Unusual shapes and curves direct the eye from one element to another and back again. Glossy white paper provides context and balance for the visually heavy duotones.

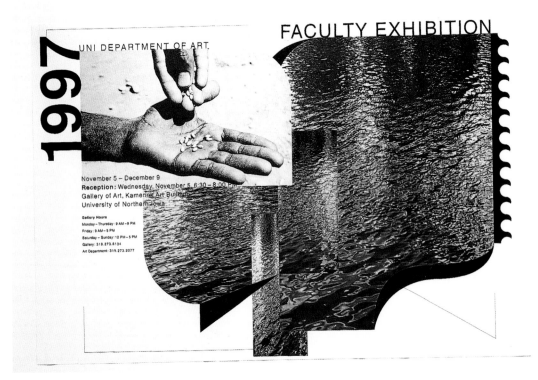

White space provides context for the photographs, reproduced as black and silver duotones, and helps create the illusion of perspective. The poster folded to double as a mailer, so a white background also helped it mail more easily.

design > Tharp Did It
illustrator > Don Weller
photographer > Phil Hollenbeck
paper > Crane's Crest 100% Cotton
client > The Design Conference That Just
Happens to Be in Park City
colors > Four-color process
printing > Offset
size > 36" x 24" (91 cm x 61 cm)

>> Less is more in this poster for an annual design and ski conference. The startling image—a designer's portfolio holding skis—and the conference's initials in bright red explain all to designers used to receiving yearly promotions. The date on the portfolio tag supplies all the information they need.

White space adds impact to the illustration and, at the same time suggests snow. "Although four-color process was used, the concept was strengthened by the sparse use of color," says designer Mr. Tharp. "A shadow under the portfolio/ski case implies snow-covered ground."

White space showcases the concept of this poster for a design conference. The deliberately dramatic treatment of the illustration and conference initials add to the humor of their content.

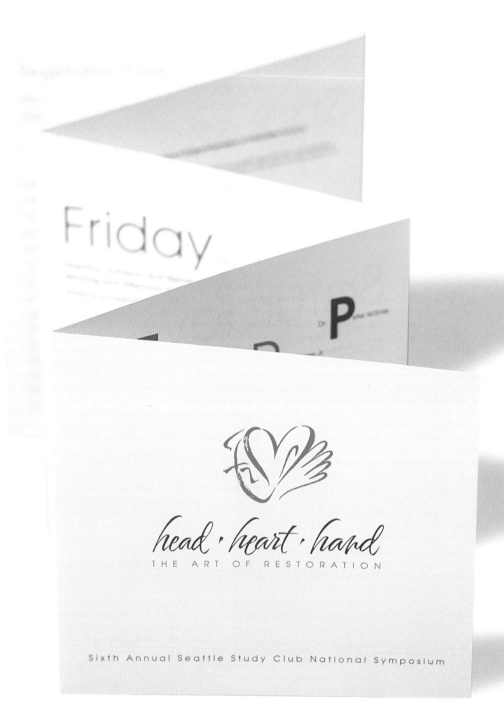

Friday

head · heart · hand
THE ART OF RESTORATION

Sixth Annual Seattle Study Club National Symposium

Although this low-cost brochure is nearly all white, its diagonal cut and accordion folding made it stand out. It fit in a standard envelope, and the detachable registration form at the dotted line fit in a business envelope.

art director > Andrea Hoffman
designer > Andrea Hoffman
illustrator > Ivan Angelic
client > Seattle Study Club
client's business > Symposium Organizer
printer > Alpha
paper > Ninah Classic Crest
colors > Two
printing > Offset
size > 9 ¹/₂" x 35" (24 cm x 89 cm)
print run > 5,000

>> After several years of producing expensive brochures for its symposia, the client wanted to cut costs, "yet keep the design very different from a traditional brochure, a trait the previous pieces had in common," the designers explain. A two-color brochure met the low-cost criteria, and the distinctive use of white space met the creative goal. The finished piece, nearly all white, stood out from the full-color pieces recipients were used to.

Small graphics in tropical colors floating on a sea of white captured the feel of Florida, the symposium's setting. The diagonal shape of the brochure and distinctive folding, while not expensive (the trim was made without a die cut), made it stand out from typical pieces—and also recalled sails or sand dunes, adding to the nautical theme.

The designers also fit menu cards, business cards, and other small items into the leftover section, creating matching collateral and saving the client more money. The clubs who received them, the designers report, flooded the client with requests for "more of the interesting white brochures," and the conference quickly sold out.

The crisp white paper stock has a substantial, weighty feel. Designers used white space and bright colors to create a tropical feel that reflected the symposium's Florida setting.

Wedding Invitation
Sagmeister, Inc.

art director > Stefan Sagmeister
designer > Stefan Sagmeister
client > Tom and Tina
printer > Moriant
paper > Crane
colors > One
printing > Offset
size > 6" x 6" (15 cm x 15 cm)
print run > 300

>> A unique combination of paper and silk bring this interactive wedding invitation to life. Printed on Japanese vellum paper and wrapped in silk, the invitation was a lush treat for the eyes and the hand. Enclosed instructions told recipients to float the piece of white silk on warm water and to place the printed circle with the dancing couple on top. "The couple started to literally dance on silk," the designer says, "and that's what marriage is all about."

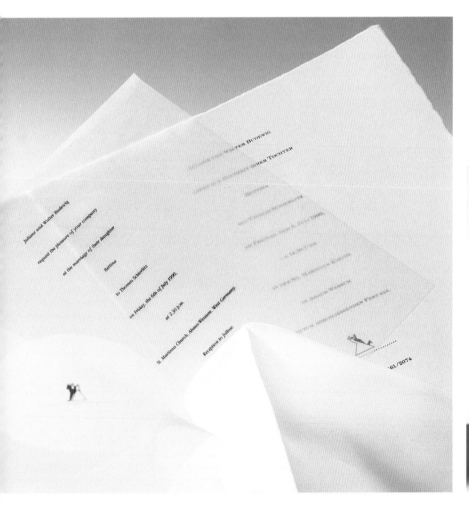

To many people, white and weddings are synonymous. Here a piece of plain white silk and an invitation printed on white Japanese paper together made a luxurious and interactive invitation.

Spare text and tiny illustrations made the white papers and fabric the visual and emotional focus. The small graphics, printed in black, provided all the vital information about the wedding, but they remained visual accents to the textured white paper and soft white silk.

art director >	Henrick Bo
designer >	Henrick Bo
client >	Self
colors >	Two
printing >	Offset

>> In the world-famous tradition of Danish design, bold color and type work with white space to create a simple, functional letterhead. "By using the red bar in combination with white, I'm signaling Danish design," says Henrick Bo, who arranged his logo vertically to inspire curiosity and chose the black and white ink combination, in part, because it made a visual impact from a distance.

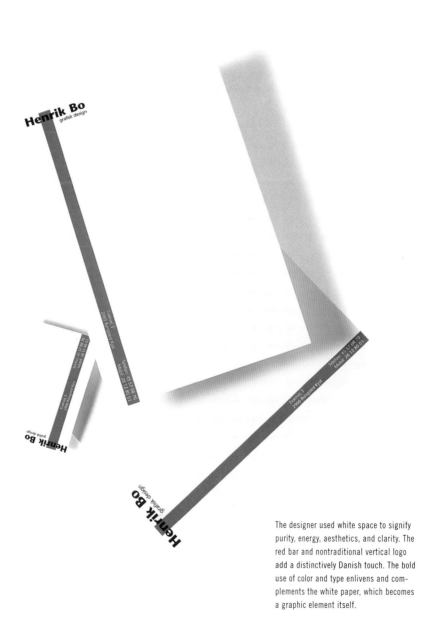

The designer used white space to signify purity, energy, aesthetics, and clarity. The red bar and nontraditional vertical logo add a distinctively Danish touch. The bold use of color and type enlivens and complements the white paper, which becomes a graphic element itself.

art director > Jane Kobayashi
designer > Jane Kobayashi
photographers > Various
copywriter > Michelle Bekey
client > Japanese American National
Museum
printer > Foundation Press
paper > Topkote Dull and UV Ultra II
colors > 5/2 plus varnish (cover);
one plus varnish (text)
printing > Offset
size > 7 ½" x 10 ½" (19 cm x 27 cm)

>> The book's dual purpose as an annual report and a marketing piece made design a top priority. Art director Jane Kobayashi made white space — a necessity because of budget constraints — a vital part of the piece's look. She kept color to a minimum on the UV-coated cover, introducing the stylish use of white space that continued throughout.

"The UV Ultra White translucency adds a nice dimension to the photography and overall effect," Kobayashi says. "It gave the book a nice layering and helped meld typography, imagery, and white space."

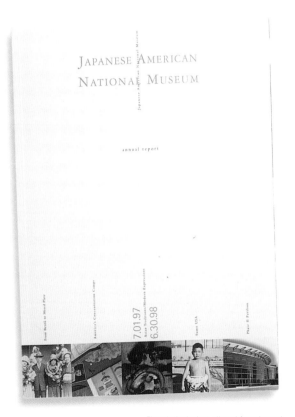

Though the budget allowed for color and a metallic ink on the cover, the designer chose to downplay color imagery and to introduce the abundant white space found within. White space allows the thick, UV-coated paper to communicate a sophisticated elegance.

visual interest. Here text printed on a
vellum sheet reveals a photo beneath it
and contrasts with a full-page photo of
a sumo wrestler.

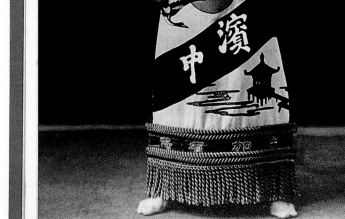

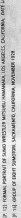

to Museum collections, databases
and other materials on site or via
the Internet. The demanding effort
required us to hone the NRC con-
cept, decide what resources to make
available through what channels,
develop crucial software and carry
out numerous other tasks. Among
the results: access to books, periodi-
cals, videos, life history recordings
and easy-to-use workstations at the
Pavilion, as well as the ability to
view many Museum artifacts on
request. Electronic visitors can tap
into Museum databases, highlights
of past exhibitions and selected col-
lection items online. Research assis-
tance is available both in-person and
remotely, for audiences ranging
from casual browsers to university
professors.

Meanwhile, we launched the innova-
tive National Media Center to offer
state-of-the-art facilities, tools and
expertise for documenting the
Japanese American experience.
Directed by award-winning filmmak-
er Robert Nakamura, the Center's
responsibilities range from develop-
ing our media strategy to providing
studio, post-production and editing
facilities. Projects include archival,
documentary and artistic footage,
both for the Museum and in collab-
oration with other institutions. Not
incidentally, we also worked to deliv-
er other revenue-generating capabil-
ities at the Pavilion, such as the
expanded Museum Store, that will
offer visitors a quiet interlude and
unusual items to carry home.

The resulting structure is an extraor-
dinary achievement for the Museum
and its supporters. Designed by
renowned architect Gyo Obata of
Hellmuth, Obata & Kassabaum and
built under the supervision of facili-
ties chairman Robert Volk and staff
members Jim Surwillo and Nancy

Araki, the Pavilion combines a dra-
matic exterior with a restrained,
flexible interior — an ideal setting
from which to expand our scope.
Landscape architect Robert Murase
and signage consultant Kiku Obata
also were instrumental in shaping
the project's successful outcome.

The lively opening celebration, which
drew a gratifying 35,000 attendees,
will be detailed in our upcoming
Commemorative Book. But in sum-
mary, the weekend-long event unit-
ed Museum supporters with national
and state representatives, Japanese
government officials, prominent arts
and cultural institutions, Los Angeles
civic leaders, local ethnic and cultur-
al organizations, and our Little Tokyo
neighbors. It also received extensive
media coverage, catapulting the
Museum onto a highly visible, inter-
national stage.

EXHIBITIONS: CHALLENGES AND
COLLABORATIONS

One of our highest-profile exhibi-
tions was the opening of *America's
Concentration Camps: Remembering
the Japanese American Experience* at
the Ellis Island Immigration Museum.
Curated by Karen Ishizuka, the exhi-
bition chronicles the chilling removal
of 120,000 United States citizens
and legal residents from their homes
during World War II. Ellis Island
officials, who feared offending New
York's Jewish community, threatened
last-minute cancellation if the words
"concentration camps" were not
removed from the title.

Our response was that the Museum
fully respects the horror of the Nazi
death camps, yet seeks to avoid
downplaying the harsh reality
Japanese American endured. We
also solicited opinions from museum
professionals, scholars and Jewish

p. 13

Japanese American National Museum

[P. 12] FORMAL PORTRAIT OF SUMO WRESTLER MITSUGU HAMANAKA, LOS ANGELES, CALIFORNIA, DATE UNKNOWN.

[P. 15] GROUP OF EIGHT SUMOTORI, SACRAMENTO, CALIFORNIA, NOVEMBER 1928.

Rob Goldman Photography Letterhead
Liska + Associates

creative director > Steve Liska,
Liska and Associates Chicago

designer > Susanna Barrett,
Liska and Associates New York

photographer > Ron Goldman

client > Ron Goldman Photography

printer > Peter Kruty Editions

paper > Mohawk Superfine,
Ultrawhite Eggshell

colors > One

printing > Offset, letterpress

print run > 1,000

>> The *camera obscura*, or pinhole camera, inspired the design for this letterhead package for a photographer. Instead of reproducing photographs or using illustrations of cameras, the black and white pieces themselves symbolize photography. Each white piece is printed solid black on one side and die-cut with a pinhole. Recipients can look through the tiny holes and see the world through the mock camera lens. Letterpress printing adds an understated note of quality, suggesting the photographer's attention to detail.

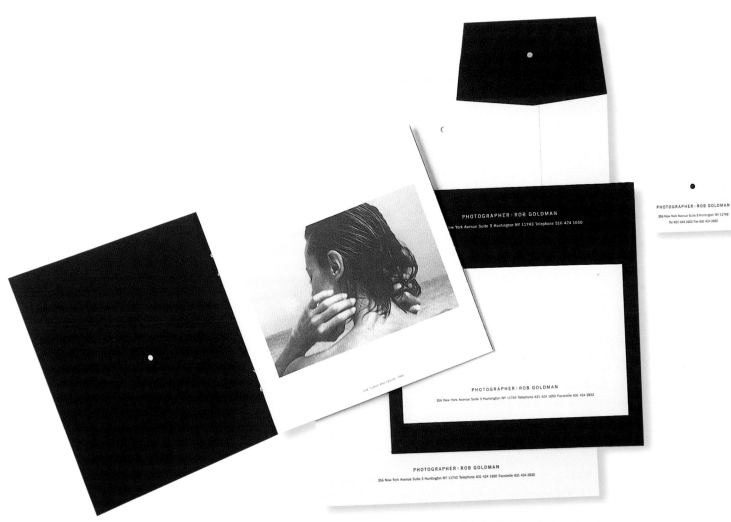

PHOTOGRAPHER : ROB GOLDMAN
New York Avenue Suite 3 Huntington NY 11743 Telephone 516 424 1650

PHOTOGRAPHER : ROB GOLDMAN
356 New York Avenue Suite 3 Huntington NY 11743
Tel 631 424 1650 Fax 631 424 2832

PHOTOGRAPHER : ROB GOLDMAN
356 New York Avenue Suite 3 Huntington NY 11743 Telephone 631 424 1650 Facsimile 631 424 2832

PHOTOGRAPHER : ROB GOLDMAN
356 New York Avenue Suite 3 Huntington NY 11743 Telephone 631 424 1650 Facsimile 631 424 2832

A double hit of ink makes the back of each piece in the system solid black. Letterpress printing gives the photographer's name and address more weight, and the unusual square business card is printed on heavy board, making it even more distinctive.

The matching eight-page direct
mail piece, mailed in a black envelope,
reproduces dreamy examples of
the photographer's work floating in
white space.

Packing Tape
Refinery Design Company

art director > Michael Schmalz
designer > Michael Schmalz
copywriter > Daniel Schmalz
client > Self
printer > Uline
colors > One
printing > Flexography
size > 3 inches wide (8 cm)
print run > 300 rolls

>> Design firms frequently tantalize their clients with printed items, adding graphic design to objects so mundane they're rarely noticed. Refinery Design Co. added punchy type and humorous copy to ubiquitous packing tape, showing how graphics can transform even the most utilitarian objects.

Designer Michael Schmalz says graphics allow the tape to serve two purposes: practical and decorative: "The white tape enhances the design, because it contrasts with the packing material." Opaque enough to make a broad white band on darker envelopes and boxes, the white tape contains and enhances the type's vitality.

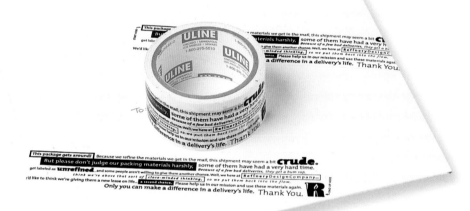

White packing tape printed with an energetic arrangement of type makes a bold graphic statement on dark envelopes and boxes. Humorous copy begs the recipient not to "judge our packing materials too harshly" because "some of them have had a very hard time." The copy also urges recipients to recycle or reuse the packaging.

art director > Burkey Belser
designer > Burkey Belser

>> Created by the same designer who designed the nutrition labels for the U.S. government, the drug facts label introduced in 1999 has a similar, yet distinct, look. The design parameters, says Burkey Belser, were tight-the labels had to be small, to fit into tiny drug packages, and had to reproduce well on extremely lightweight paper. And because drug companies had to pay for redesigning their existing packaging to include the labels, cost had to be kept as low as possible.

To meet those criteria, Belser says, "White was the only choice. White organizes complex information with a power no other color can bring. And it looks official and credible in the high-intensity advertising environment common in drug packaging."

Drug Facts

Active ingredients (in each tablet) — Purpose
Chlorpheniramine ..Antihistamine

Use temporarily relieves these symptoms due to hay fever or other respiratory allergies:
- sneezing
- runny nose
- cough
- nasal congestion

Warnings
Ask a doctor before use if you have
- glaucoma
- a breathing problem such as emphysema or chronic bronchitis
- trouble urinating due to an enlarged prostate gland

Ask a doctor or pharmacist before use if you are taking tranquilizers or sedatives

When using this product
- you may get drowsy
- avoid alcoholic drinks
- alcohol, sedatives, and tranquilizers may increase drowsiness
- be careful when driving a motor vehicle or operating machinery
- excitability may occur, especially in children

If pregnant or breast-feeding, ask a health professional before use.
Keep out of reach of children. In case of overdose, get medical help or contact a Poison Control Center right away.

Directions

adults and children 12 years and over	take 1 tablet every 4 to 6 hours; not more than 6 tablets in 24 hours
children 6 years to under 12 years	take 1/2 tablet every 4 to 6 hours; not more than 3 tablets in 24 hours
children under 6 years	ask a doctor

The new white drug facts label now used on all medicines in the United States relies on outline boxes and type weight to convey a great deal of complex information. More cluttered than the food nutrition labels also designed by Burkey Belser, they have a similar look. Consumers used to looking at one can easily understand the other.

Wedding Invitation
Chris Rooney Illustration/Design

designer >	Chris Rooney
illustrator >	Chris Rooney
copywriter >	Chris Rooney
client >	Denise Rooney, Gregory Bruen
printer >	Classic Letterpress
paper >	Somerset Textured White
colors >	One
printing >	Letterpress
size >	19 1/2" x 6" (50 cm x 15 cm) (unfolded)
print run >	250

>> To match his sister's wedding color scheme—all white with only a touch of purple—designer Chris Rooney created an invitation both traditional and modern. Heavy white paper provides the perfect background for a narrow band of illustrations and copy. Letterpress printing adds a luxurious feel.

"The bride and groom wanted to convey some of their personalities and the milestones in their lives that led up to their special day," says Rooney. "This was a wedding gift, so I determined the budget and specs. The accordion-fold invitation was longer than most letterpress printers would allow. But in the end, I found the right printer and the budget worked out to be about what I expected."

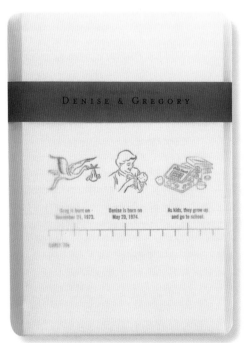

A translucent, off-white envelope with a built-in pocket holds the invitation, revealing the band of illustration inside. A belly band printed with the wedding couple's names adds an elegant touch and introduces the color purple.

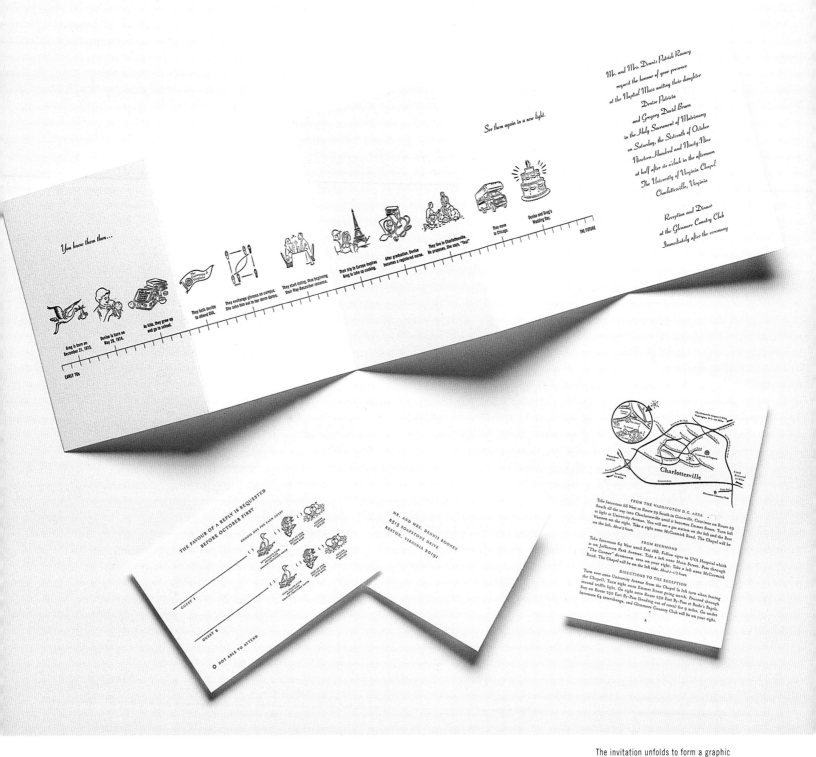

The invitation unfolds to form a graphic timeline. Clip art-style images present key moments in the wedding couple's lives. Heavy white paper frames the illustrated band, providing a luxurious feel and showcasing the elegant letterpress printing. Even the map card was letterpress printed, creating a truly elegant package.

Face to Face with the Future
Sage

art director > Vicki Strull
designer > Catherine Wells
photographer > Marilyn Suriani
client > Metro Atlanta YMCA
printer > Graphic Press, Inc.
paper > Appleton Lucence (cover);
Mead Signature (text)
colors > Seven
printing > Offset
size > 7 ¼" x 8 ½" (18.5 cm x 22 cm)
print run > 3,600

>> Black and white photographs of youthful faces feature throughout this book, the 1998 annual report for the Metro Atlanta YMCA. White links the text and images, showcases the fine photography, and acts as an additional ink color on colored pages.

"The faces on the front and back covers create a powerful image of the future, which is literally glimpsed through the vellum cover," says Sage principal Vicki Strull. "Restrained layout and the poignant use of white space reinforce the Y's serious commitment to their vision and goals."

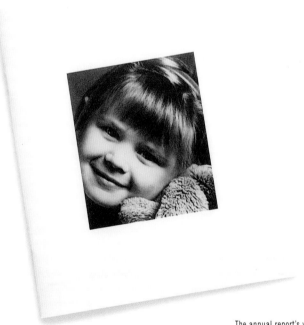

The annual report's vellum cover features photographs of children's faces. The white vellum stock is opaque enough that the front photo covers and hides the report's title, except for the word *future*.

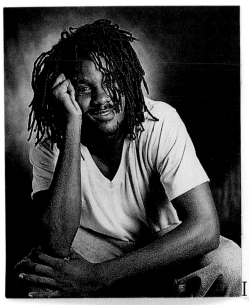

Through the work of scores of people inside the Metro Atlanta YMCA and out, we follow the theme, image and agenda outlined in the Y-2001 strategic plan. Our vision for the future is clear and unwavering — to be the premier family resource organization in metro Atlanta and an effective catalyst for community improvement. The YMCA continues the important, positive contributions to the quality of life in our community by:
· providing values-centered programs for children;
· addressing the real issues of teenagers;
· forging new partnerships in the community;
· strengthening the spirit, mind, and body of youth, families and adults.

The Metro Atlanta YMCA is open, accessible, dynamic, progressive, responsible. Quality programs and services provide an opportunity for personal growth and service to others. Guided by values and inspired by imagination and innovation, the Metro Atlanta YMCA promotes strong families; healthy, self-confident children; and united communities.

I am the future

Bright white paper sets off fine reproductions of black and white photographs, which create the report's main graphic impact. Generous white space surrounds the text and oversized headlines, making squares and lines of type into graphic tools.

On colored pages, white takes the place of a third ink color. Here white adds to the layered and multisized type, creating visual interest without ruining readability.

"
partnerships

Centennial Place emphasizes child, family and economic development. This neighborhood symbolizes what Atlanta can accomplish when everyone works together.
— Renée Lewis Glover, executive director, Atlanta Housing Authority

"Today's youth are less cared for, less healthy and less prepared for life...all are at-risk. It is a crisis reaching into every neighborhood. Through strong leadership, thoughtful vision, and innovative programs, the YMCA is providing compelling, effective answers to many of today's young people."
— Judge Glenda Hatchett, Chief Juvenile Court Judge of Fulton County

character development

"The responsibility for learning is shared by the whole community. The YMCA creates an atmosphere where children feel safe, are surrounded by caring adults who act as role models, and interact with peers."
— Cynthia Kuhlman, principal, Centennial Place Elementary School

"

health enhancement

"Northside Hospital is involved with the YMCA because it contributes to the community's well-being. Northside Hospital's programs — whether health screenings, physical rehabilitation, or prenatal care — extend the YMCA mission."
— Sidney Kirschner, president/CEO, Northside Hospital

Sage T-Shirt
Sage

art director > Vicki Strull
designer > Vicki Strull
client > Self
colors > One
printing > Screenprinting

>> Sage, a boutique design studio, chose its name for its multiple meanings. Just as the word can't be pinned down, the studio practices numerous design disciplines. But for its own identity, designers chose the word's botanical meaning, using sophisticated white space, sage green ink, and minimalist layout to imply a high-end practice.

This t-shirt promotion uses a sophisticated sage leaf print to communicate that message. Printed on the white t-shirt and white business cards tied to the shirt with twine, the design "conveys the personal attention given to the clients," says principal Vicki Strull. "The white space expresses a sophisticated understanding of composition."

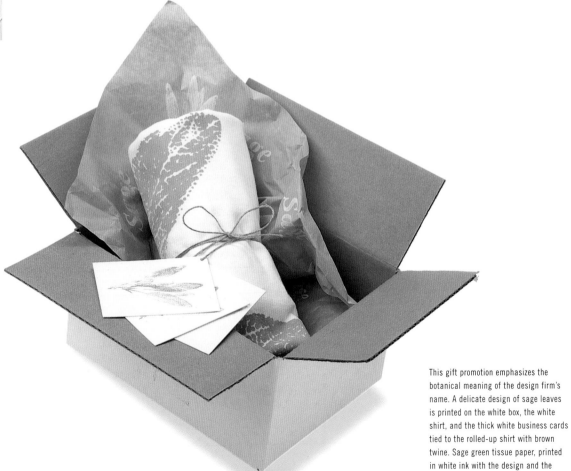

This gift promotion emphasizes the botanical meaning of the design firm's name. A delicate design of sage leaves is printed on the white box, the white shirt, and the thick white business cards tied to the rolled-up shirt with brown twine. Sage green tissue paper, printed in white ink with the design and the firm's name, lines the box.

art director > Oscar Fernández
designers > Andreas Kranz, David Bull
copywriters > Doug Burdick, George Felton
production > Shelly Pomponio
client > Columbus Society for the
Communicating Arts
client's business > Arts organization
printers > J. F. Hopkins and Associates,
Westcamp Press, Dispatch
Color Press
papers > Fraser Mosaic, Appleton Papers
Utopia, Consolidated Centura
Gloss Text
colors > Four-color process
printing > Offset
size > 8 ½" x 8" (22 cm x 20 cm)
print run > 3,000

>> Like most booklets for design organization contests, this piece had a dual purpose: to showcase the competition winners and to showcase the papers donated for the project. White space is used generously throughout to meet both goals.

The cover image reveals a heavy flecked paper with a matte finish. The chosen inks sink into the paper so that both have equal impact. Inside, winning designs are printed on glossy coated paper, popping off the page.

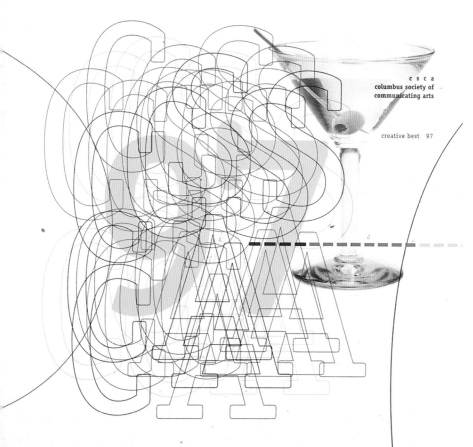

Inside, winning designs printed on glossy coated paper appear to pop off the page. Computer-generated shadows beneath photographs help them stand out. Here type and color give impact to a winner for copywriting, allowing readers to see the copy without looking through the piece.

While few clients would appreciate such a cover image, designers can cut loose when they create for each other. The martini glass and number are instantly recognizable, while the sponsoring organization's initials (perhaps viewed after too many martinis?) are less obvious. The inks and white paper balance each other so that both have equal impact.

Proof: VIA Direct Mail Pieces
VIA, Inc.

art director >	Oscar Fernández
designer >	Oscar Fernández
illustrator >	Oscar Fernández
photographer >	Oscar Fernández
copywriter >	Wendie Wulff
production >	Shelly Pomponio
client >	Self
client's business >	Marketing and design
printer >	Byrum Litho
paper >	Cougar Opaque
colors >	Six
printing >	Offset
size >	5 ½" x 4" (14 cm x 10 cm)
print run >	10,000

>> A series of promotional mailers uses white space to tell the story of how successful designs were born and developed. Text, thumbnail sketches, prototypes, and photos of finished pieces show the progression of ideas to reality. Beneath the yellow-orange flap, short copy explains how each design helped the client's business.

Soft white paper adds context and organization without distracting the reader from the featured design. It also sets off the distinctive yellow-orange color chosen to unify all the pieces. "Yellow always needs white," says designer Oscar Fernández, who created the series to educate potential clients and generate brand awareness for the studio.

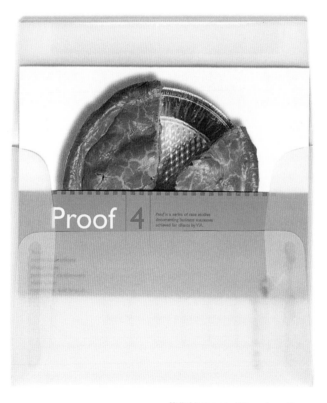

Mailed in opaque white envelopes, the series of fold-out brochures offers proof that the studio's work produces results for its clients. White space contains and shows off the photographs, sketches, and blocks of copy that tell the story of how each design developed.

Together, the series forms a unified whole. The soft white paper sets off the distinctive yellow-orange ink used on the cover flap and to showcase client information. Abundant white space keeps the pieces businesslike and dignified, despite the vibrant inks and images.

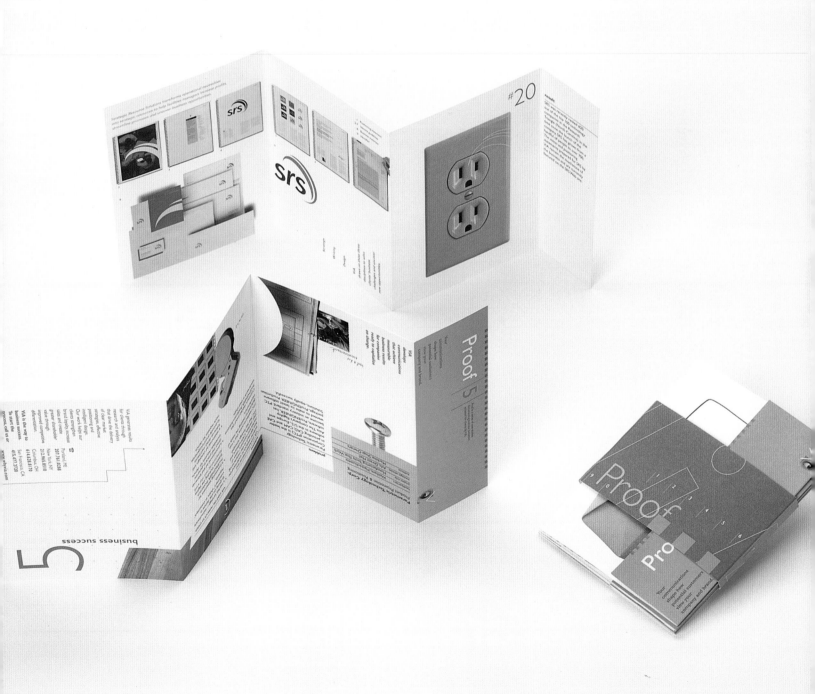

Vision Zukunft #2
Buero fuer Gestaltung

art directors > Christoph Burkardt, Albrecht Hotz
designers > Christoph Burkardt, Albrecht Hotz, Regina Schauerte
client > Kuenstlerhaus Mousonturm
client's business > Theater
colors > Two
printing > Offset, screenprinting
size > 8" x 11" (20 cm x 28 cm)
print run > 500

>> Deliberately crude in design, particularly in its photography, this book of symposium presentations appears to have been produced by students on a photocopier—at first glance. A second look reveals the artful manipulation of type, images, white space, and binding that reflects a classic German attention to detail and design.

The book's choice of papers (white with gray dividers) and inks (black with orange-brown accents) sets the deliberately low-budget look. The plastic cover, screen-printed with a simple white band, and wire binding that connects only the center third of the book don't look expensive but add careful design touches. Inside, a grid unifies the text. Generous margins and a narrow line running through the book reveal the white paper as the primary design element.

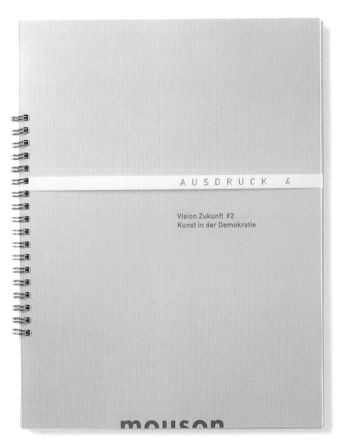

AUSDRUCK 4

Vision Zukunft #2
Kunst in der Demokratie

mouson

A clear plastic cover screenprinted in white ink reveals a few words printed in orange on plain gray stock. Spiral binding, stylishly kept to the center of the book, finishes the low-budget look.

Photos deliberately altered to look crude and stark and black type on plain white paper make this book look as if it had been run off in someone's basement—almost.

Geert Lovink

Die Ökonomie des Idealismus
Medienarbeit jenseits der Hermeneutik

Bislang standen sich Idealismus (net.activisme) und Ökonomie (bzw. E-commerce) als feindliche Blöcke gegenüber. Wir brauchen hier den Idealismus nicht zu verteidigen oder über den grünen Klee zu loben und auch nicht nachzuweisen, daß der Idealismus der Zeit nach dem Kalten Krieg nicht funktioniert. Starten wir eine Untersuchung jenseits der guten Absicht. Glücklicherweise muß nichts bekannt oder verraten werden. Auch keine Futurologie. Es geht hier nicht um Modetrends oder Börsenprognosen. Worum es geht ist Leidenschaft, Getriebenheit, Überzeugung. Und „Respekt", die Bewunderung, Liebe und Solidarität für andere, anderswo, die irgendwo sitzen und mit der Apparatur spielen. Ich nehme der Einfachheit halber an, daß diese Mentalitäten existieren. Medien sind kein Problem mehr. Sie sind einfach da, umgeben und begleiten uns. Medien, ein Freund für's Leben. Und wenn man genug hat, geht man einfach aus dem Zimmer oder drückt den Ein/Ausschalter.

Wir müssen uns hier wenig mit der Generation der sechziger Jahre beschäftigen, mit ihren hohen Erwartungen und Dogmatismen. Sie besitzen nicht das Copyright auf Idealismus. Mit derselben Verbissenheit wie ehedem vertreten sie jetzt die Privatisierung, Kommerzialisierung und den Ausverkauf der gesamten Öffentlichkeit. Ihr Glaube an die freie Marktökonomie ist ebenso ideologisch wie seinerzeit der akademische Marxismus, der durch sie verkündet

B92 und all seinen Mitarbeitern gewidmet. Ihr Slogan: „Don't trust anyone, not even us. But keep the faith!" (http://www.B92.net)

Das Programm

Vorträge	Marius Babias	Die nachfolgende Sendung wird Ihnen präsentiert von: Harald Schmidt Show. Mad Max. Postmoderne Propaganda. Marcuse revisited. Die unvollendete Moderne. Pictorial Turn	Podien	Das ist Demokratie, langweilig wird sie nie..."	Mit Isabelle Graw, Matthias Lilienthal, Thomas Mayer, Christoph Schlingensief Moderation: Susanne Winnacker
	Ute Meta Bauer	Meinen Arbeitsplatz gibt es noch nicht		Kunstgenuß oder Kapitalfluß?	Mit Daniel Cohn-Bendit, Alice Creischer, Diedrich Diederichsen, Kathinka Dittrich van Weringh, Ludger Hünnekens, Andreas Siekmann Moderation: Susanne Winnacker
	Clémentine Deliss	Wayward Routes / Ableitende Wege			
	Diedrich Diederichsen	Jenseits der Institutionskritik. Galerien, Clubs, Netzwerke		Schnittstelle Galerie: Vermittlungskanal der Zukunft?	Mit Matthias Arndt, Ulrich Voges Moderation: Marianne El Hariri
	Geert Lovink	Radikaler Medienpragmatismus. Internet jenseits von Gut und Böse			
	Boris Nieslony	Sich die Kreativität aus dem Leibe schlagen	Installationen	Peter Bux	Scheitern mit Lust
	Stella Rollig	Zwischen klaren Interessen und verborgenen Wünschen. Kunst und Politik		Annette Glaser und Silke Thoss	Adhocracy
				Harald Kühneke	Da geht's lang
	Tom Stromberg im Gespräch mit Susanne Winnacker	Experiment Expo		Mauricio Dias / Walter Riedweg	Inside and Outside the Tube
	Mårten Spångberg	I didn't ask for this. I just wanted a career in the legislative theatre		Sybille Ruter	Art Statements
	Florian Waldvogel	You'll Never Walk Alone	Ausstellung	Brigitte Maria Mayer	Wenn ich wüßte was ich wollte / Wahnsinniges würde wirklich
			36-Stunden-Event / Installationen / Club	anuss 2000	superplast

A careful selection of typefaces and an orderly grid reveal the skill and attention that went into the book's design. Abundant white space, the overall design statement, also reveals that it isn't an amateur production.

Food Services of America 1998 Calendar
Hornall Anderson Design Works

art director > Jack Anderson
designers > Jack Anderson, Mary Hermes,
Julie Keenan
illustrator > Dugald Stermer
client > Food Services of America
client's business > Institutional food distributing
printer > Grossberg Tyler
paper > Cougar Smooth
colors > Six
printing > Offset

>> Hornall Anderson Design Works has designed the client's calendar, its main marketing piece, for seven years. Its job is always to be useful as well as attractive. Unlike many giveaway calendars, which too often are also throwaway calendars, this features fine paper, six-color printing, and art that is attractive as well as symbolic of Food Services of America's business. Effective use of white space showcases the elegant, classic illustrations, suggesting that the client promotes fine food and cooking.

White space focuses attention on the classic, elegant illustrations of food in this calendar, the client's main promotional piece.

Mr Tharp's Card
Tharp Did It

art director > Mr. Tharp
designer > Mr. Tharp
colors > One
printing > Offset
size > 2" x 3 ½" (5 cm x 9 cm)

>> Mr. Tharp is known for his irreverent sense of humor and healthy attitude toward his success as a designer, both of which are no more evident than on his personal business cards. After all, this is the same designer who once ordered thermographed cards from a catalog at a quick-print shop, choosing clip-art images of a poodle and a chainsaw from the stock images and offering "poodle grooming, repair, taxidermy & graphic design" services.

Here Mr. Tharp (and you'd better call him Mr.) offers yet another take on the business card. "This card says just what it is: 'Mr. Tharp's Card,'" Tharp explains. "No address, no phone, no e-mail— just the designer's name and a healthy amount of white space. Enough said."

Designer "Mr." Rick Tharp means just what he says when he offers his card. Printed in burgundy ink on heavy white stock, Mr. Tharp's Card is a graphic joke—offering no more information than the three beautifully arranged words that demonstrate his masterful use of type and white space.

MR THARP'S CARD

creative director >	Steve Liska
designer >	Susanna Barrett
copywriting >	AIGA National Office
client >	American Institute of Graphic Arts
client's business >	Professional organization
printer >	Meridian Printing
paper >	Mohawk Superfine, Ultrawhite Eggshell 80# Text
colors >	Three
printing >	Offset
size >	17" x 22" (43 cm x 56 cm)
print run >	20,000

>>To introduce AIGA's new graphic identity and mission to its national membership, the organization commissioned a two-sided poster on the theme "virtuosity and velocity." One side featured an abstract image image reminiscent of moving traffic. The second presented a classic arrangement of blue and black type that explained the organization's changes.

"We printed a two-color black to add depth to the black areas and provide a greater contrast with the white space," says Liska and Associates' Deanna Retzer. "The new AIGA identity is printed in blue; the limited palette emphasized the colored logo."

The AIGA poster folded into quarters for mailing. The mysterious black and white image created a provocative mailer and unfolded into a dynamic poster recipients could display in their offices. The two-color black provided a denser look that emphasized the white space.

The poster's second side explained changes in AIGA's graphic identity, mission, and organization. Dense type was classically and attractively arranged to be as readable as possible. White space showcased the type treatment and added breathing space between the blocks of type.

White Arts Printing Brochure
Indiana Design Consortium, Inc.

art director > Kendall Smith
designer > Ellen Sprunger
photographer > Tom Casalini
copywriter > Carol Schuler
client > White Arts Printing
printer > White Arts Printing
paper > Potlatch Eloquence Silk (body);
 Strathmore Writing Double Cover
 Ultimate White (cover)
colors > 4-color process plus nine
 match colors
printing > Komori 40 in Lithrone Press
size > 8 ½" x 11" (22 cm x 28 cm)
print run > 10,000

>> An unlimited printing budget and a design objective to showcase printing techniques gave designers free rein in this brochure celebrating a printer's 50th anniversary. The company's name, White Arts Printing, inspired the white theme.

A textured white wrapper and a foil-stamped white cover introduce the piece. Inside, readers find page after page of artful photos featuring collages of white objects. The company's logo is hidden in each photo. Borders and graphics in nine match colors define and showcase the white paper and art.

A foil-stamped seal and a stamped translucent paper set the stage for the brochure's white cover, which features embossing and foilstamping. The company's symbol, a rainbow-colored "w," becomes an abstract design when stamped with white foil.

The brochure's copy describes white as "the presence of all color." Each photograph is composed of white objects with one colored object for emphasis. The colored object is repeated in a graphic on the opposite spread, and printed in varnish on the photograph's colored "frame." Each photo also contains a hidden letter "w," a string of pearls, or a piece of twine or rope arranged in the company's signature swash.

Letterhead
Lorenc + Yoo Design

art director > Jan Lorenc
designers > Jan Lorenc, Veda Sammy
Illustrator > Veda Sammy
client > Self
printer > Dicksens
paper > Astrolite
colors > 4-color process plus clear foil
printing > Offset, foil stamping
size > 8 ½" x 11" (22 cm x 28 cm)
(letterhead)
print run > 5,000

>>This letterhead package for a multidiscipline design firm captures the feel of its three-dimensional work, even as it demonstrates mastery of traditional graphics. Layered abstract shapes symbolize the forms, layers, and style of the firm's sign and exhibit work. The classic Swiss-style arrangement of type, color, and white space, combined with an unusual printing technique, show off two-dimensional skills.

Foil stamping over a printed gray gives this piece its unique look. "White allowed the marigold yellow to float and the blue-gray to be glasslike in its transparency," says principal Jan Lorenc. "I really wanted the cards engraved, too, but that would have been like giving away $2 instead of a business card, so I had to restrain myself."

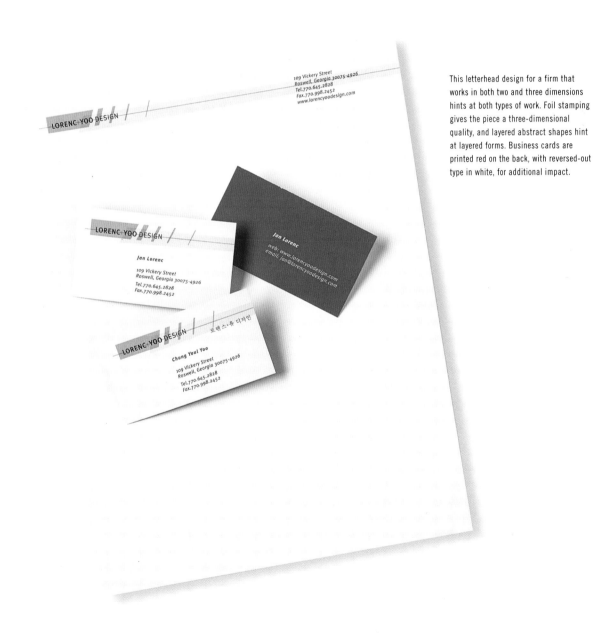

This letterhead design for a firm that works in both two and three dimensions hints at both types of work. Foil stamping gives the piece a three-dimensional quality, and layered abstract shapes hint at layered forms. Business cards are printed red on the back, with reversed-out type in white, for additional impact.

365 Ben Days
VSA Partners

concept and design > Dana Arnett, Ken Fox, Fletcher Martin, John Naresky
photographer > Scott Shigley
cover illustration > Québec/Amérique International
client > Potlatch Corporation
client's business > Paper manufacturing
paper > Potlatch 120# Vintage Gloss (cover); 80# Karma Bright White (text)
colors > Three plus varnish and overall aqueous coating (cover); various (text)
printing > Offset

>> Created to follow the success of Potlatch Corp.'s *Ben Day* film, a black comedy about a fictional superstar designer, this 1997 desk calendar emphasizes on black and white while incorporating color photos, spot colors, and tritones. White calendar pages follow the design sensibility of the film's printed collateral, including dates set in "Cueless," a made-up typeface with no letter Q.

Playful copy—quotes by the *überdesigner*, such as "I keep turning the tables on people so often that I need to use a Lazy Susan," and the supposed dates various great designs were completed—are interspersed with photographs of the actor who played Ben Day. But unlike many designer-produced calendars, this one remains eminently functional.

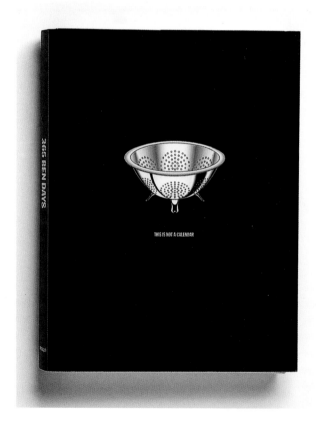

Poking fun at deliberately ambiguous design, the cover illustration of a colander sits above the statement "This is not a calendar." The illustration is printed as a tritone with two blacks and a gray; the white letters are knocked out of the solid black. An aqueous coating creates greater depth.

Like many calendars, this includes
a section of "helpful information,"
including tips on dressing for meetings,
useful Swahili phrases, and charts of
beef and poultry cuts. Type is artfully
arranged on the white pages.
Photographs are reproduced as tritones.

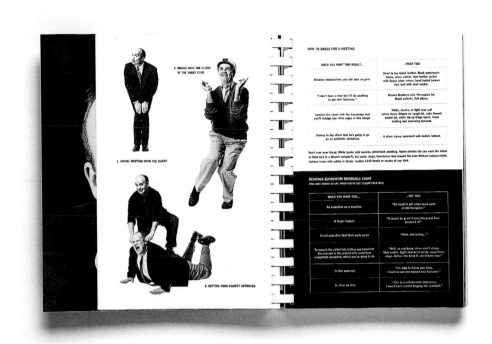

Unlike many designer calendars, this
one includes plenty of space for writing,
making it functional as well as clever.
The black and white color scheme both
made the piece easy to use and showed
off the paper being promoted. This
December page is faced with Ben Day's
"breathtakingly stylish" design for an
atomic bomb.

design > Tharp Did It
client > Mariann Grace Photographer
client's business > Photography
paper > Crane's Crest 100% Cotton
colors > Two
printing > Letterpress
size > 8 ¹/₂" x 11" (22 cm x 28 cm)
(letterhead);
2" x 3 ¹/₂" (5 cm x 9 cm) (card)

>> "When designers refer to negative space, they are usually referring to white space," explains Mr. Tharp. "But with this stationery suite, 'negative' means 'negative.'" Fine printing and three-dimensional touches bring distinction to this essentially white piece, showcasing the 100% cotton rag paper stock.

"The very tiny die-cut hole in the black box implies a pinhole camera," Tharp says. "Letterpress typography and a subtle blind-embossed border on the card add a dimensional quality." The logo is printed in black and the address in gray, a two-color printing job so subtle that many might miss it.

The tiny die-cut hole in the black cube symbolizes the venerable pinhole camera. The hole is big enough for clients to look through and, for a moment, see the world through a camera lens.

MARIANN GRACE ■ PHOTOGRAPHER

MARIANN GRACE
PHOTOGRAPHER

825 SIR FRANCIS AVENUE CAPITOLA, CA 95010 USA
PHONE: 831.475.1442 FAX: 831.462.9691 EMAIL: MG@MARIANNGRACE.COM

The high-end printing techniques used in this letterhead package are so subtle that only the most discerning clients will notice: letterpress printing, embossing, a tiny die-cut hole no bigger than a pin head, and two-color (black and gray) printing on top-quality white cotton rag paper. The result is a package that shows exquisite attention to detail and refined taste.

Sci-Arts Spring Lectures Poster
Jennifer Sterling Design

art director > Jennifer Sterling
designer > Jennifer Sterling
Illustrator > Jennifer Sterling
photographer > Marko Lavrisha
copywriter > Lisa Citron
client > Southern California Institute
of Architecture
printer > Bell Aire Displays
size > 48" x 70" (122 cm x 178 cm)

>>White space provides a grid organizing this giant poster for a series of lectures about architecture. Mysterious images, bright matte colors, and provocative arrangements of type complement the chalky white paper stock. A grid of dotted lines seems to invite the reader to cut the poster into individual rectangles, perhaps to assemble them into a book.

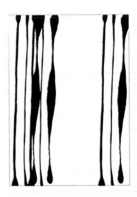

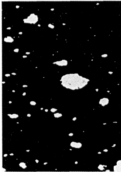

The unusual chalky white paper is revealed by many of the small rectangular designs and by the spaces between them. The white grid contains and separates the bright, energetic designs, keeping them from overwhelming the viewer (and the message).

Whites Paper Marketing Package
Walker Thomas Associates

art director > Catherine Thomas
designer > Paul Monkivitch
photographer > Andreas Lipsys
client > Dalton Fine Paper
client's business > Paper merchant
printer > Bambra Press
paper > Byronic
colors > Four-color process
printing > Offset
size > A4 plus inserts
print run > 3,000

>> Designers used white space to reveal the physical qualities of a new line of white papers to be marketed throughout Australia. The package required an eye-catching design, but one that revealed much of the paper being marketed. Cricket provided the perfect inspiration.

"Australia is a sporting nation and fanatical about cricket," say the designers, "not least because it affords ample opportunities to ridicule their ex-colonial masters in England. White is the color of cricket, and so seemed the perfect topic to promote white paper in an Australian market."

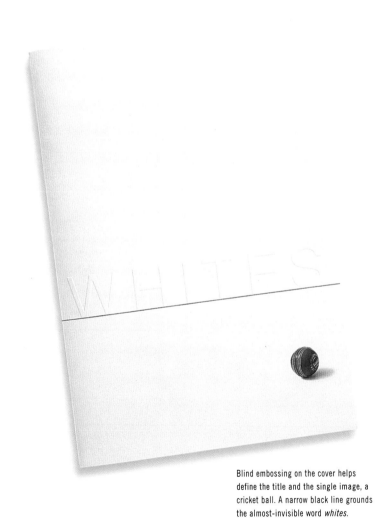

Blind embossing on the cover helps define the title and the single image, a cricket ball. A narrow black line grounds the almost-invisible word *whites*.

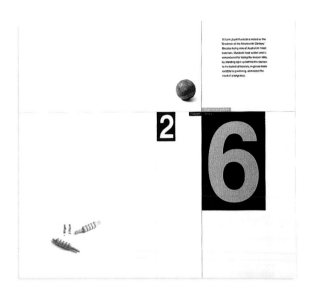

Designers rounded up cricket memorabilia from their families to keep the photography budget low.

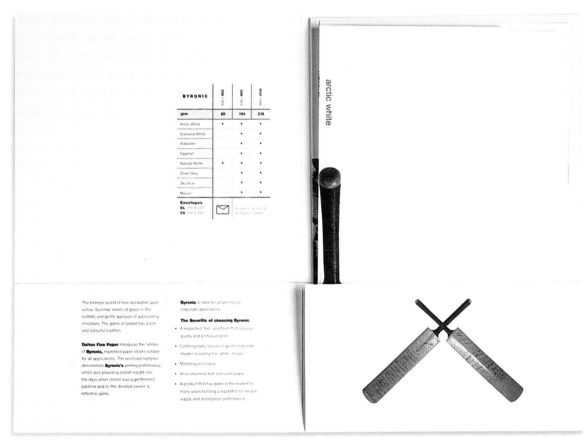

Imagery demonstrates the paper's printing qualities, while provocative use of white space shows off its natural color and texture. Short copy recalls great moments in cricket.

art director >	Jack Anderson
designers >	Jack Anderson, John Anicker, Mary Hermes, Margaret Long
photographer >	Corbis Archive
client >	Corbis Corp.
client's business >	Digital image archiving
printer >	Grossberg Tyler
paper >	Classic Columns, Red Pepper (cover); Potlatch Vintage Velvet Remarque Book
colors >	Four-color process plus one match metallic and varnish
printing >	Offset
size >	10 ½" x 10 ½" (27 cm x 27 cm)

>> Foil-stamped and embossed, the red cover of this brochure for stock images makes an immediate, strong statement—with type. The photographs themselves are hidden inside. Far from a compendium of available artwork, the book resembles a catalog from an exhibition of pieces from the Bettman Collection. It suggests that the images are a sample of something much larger, with the ultimate aim of enticing readers to go to the company's web site.

The photos and artwork, a selection of pieces from many decades, are show-cased by the clever use of white space. Creative layouts subtly suggest ways to use the images in designs. "The use of open layouts and larger white spaces enabled the catalog to be image oriented, instead of just a parts catalog" the designers explain.

The embossed and foil-stamped cover, made of French-folded red textured paper, gives way to a white translucent fly sheet that half reveals a full-bleed photo.

the bettmann collection

the past is ever present

Varnish provides extra contrast with the velvety white paper, making the featured photos seem to jump from the page. A timeline running along the bottom of every page highlights historic images and suggests the collection's huge size.

Besides showcasing the Bettmann collection of images, the catalog demonstrates creative ways to use them. Here type, an amusing full-page photo, and cut out images create a collage.

Guests were encouraged to add their own color to the white space in the paper doll invitation and coloring book favor. Cartoon illustrations and coloring-book activities add to the charm and prove that graphics aimed at children are still appreciated by adults.

Birthday Invitation and Coloring Book
Wooly Pear

designer > Lana Le
illustrator > Lana Le
copywriter > Ransom Bruce
client > Self
printer > Self
paper > Classic Crest Solar White
colors > One
printing > Laser
size > 5" x 7" (13 cm x 18 cm)
(invitation);
5 1/2" x 5 11/16" (14 cm x 15 cm)
(book)
print run > 50

>> For an "anti-thirtieth birthday" party held in a preschool, designer Lana Le produced her own invitation and favor. "The idea was inspired by children's paper dolls and coloring books, which consist of line drawings and lots of white space," says Le. "The low budget dictated the printing method and use of pink paper to provide a second color."

Le offered a prize to the best party dress for paper doll "Little Lana," who offered to be best friends with whoever came. Cartoon pets and friends enliven the coloring book, which offered guests connect-the-dot and word search activities.

little lana
was born 3 years ago on october 6

come & play with me
i'm turning 3

little lana

"Little Lana" may look only three, but turn over the pink band holding the invitation and you'll find the missing zero. Designer Lana Le's cartoon alter ego provided an ingenious twist to the one-color, self-produced piece. The children's coloring book theme made white space a design feature.

Stripes and Stars
Pentagram Design, Inc.

design > Pentagram Design, Inc.
photographers > Bob Esparza, Terry Heffernan
copywriter > Delphine Hirasuna
client > San Jose Museum of Art
printer > H. MacDonald Printing
paper > Potlatch
printing > Offset

>>White space frames and surrounds the objects displayed in this tiny museum catalog, which documented an exhibit of flag-themed objects from the collection of Pentagram designer Kit Hinrichs. Arranged in the classic style familiar from Pentagram, the quirky fans, buttons, spoons, and other items—even a kimono—take on an aura of importance and history. White space provides pleasing visual context for the objects and demonstrates how design gives meaning and sense to otherwise unrelated or unremarkable things.

White pencils printed with various designs become the white bars of the American flag on this cover for an exhibit catalog. For Americans, the red, white, and blue colors of the national flag have many meanings.

When presented as cutouts on crisp white paper, objects seem important and meaningful. These spoons have nothing in common but the American flag. Assembled as a collection and printed against a stark white background, they become symbols of an American sort of pride.

art director > Esther Bridavsky
illustrator > John Meyer
client > *Metropolis* magazine
size > 10" x 12" (25 cm x 30 cm)

>> An illustration by visionary train designer John Meyer, whose work and philosophy is featured inside, provided an intriguing cover for the redesigned Metropolis. The magazine is known for its wide-ranging and thought-provoking articles on architecture, culture, and design. The cover, with its bizarre diagram hinting at an even more bizarre scheme, appeals to readers' eclectic tastes. White space, rare on magazine covers, is here in abundance.

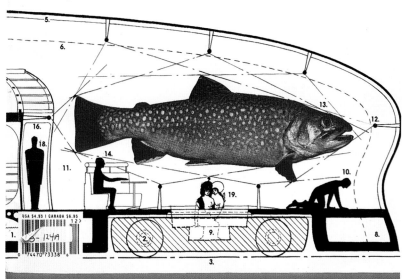

White space gives this magazine cover the look of an architectural drawing. The fanciful diagram visually balances the magazine's logo, which doesn't fit inside the page, and its small teaser copy. The result is a cover that stands out against other architecture magazines, which usually feature photographs. A round black sticker with ghosted white lettering announces with understated irony that the magazine has been redesigned.

Limn Letterhead
Jennifer Sterling Design

art director > Jennifer Sterling
designer > Jennifer Sterling
illustrator > Jennifer Sterling
copywriter > Dan Friedlander
client > Limn
client's business > Retail store and gallery
colors > One (brown version);
two (pink version)
printer > H. MacDonald
printing > Offset and letterpress
size > Standard U.S. (sheet and
envelope); 2 7/16" x 2 7/16"
(6 cm x 6 cm) card

>> Two letterhead designs for a store and gallery featuring furniture and other elegant accessories share the same design sensibility. Abstract design, distressed type, and only a hint of color give both designs an overall emphasis on white that fits the client's high-end business. Only the distinctive square business cards emphasize color, and they use white (ghosted from the full-bleed image) as an accent.

Both designs feature only a hint of color floating in clean white space. The abstract designs, distressed type, and letterpress printing add appropriate high-style touches. A tagline, "where art and design meet," is blind embossed at the bottom of each stationery sheet for another subtle statement.

LIMN

After my own heart.

love

knows

nothing

limn_g

of order.

From the Desk of Twenty-Five
San Francisco Designers
Pentagram Design, Inc.

design > Pentagram
photographer > Bob Esparza
copywriter > Delphine Hirasuna
printer > Bofors Lithography
paper > Potlatch McCoy Velvet #100
 Cover and Gloss #100 Text
printing > Offset

>> A promo that's both a portfolio and a puzzle, this booklet of photographs invites readers to decide which "artifacts" come from the desk of which San Francisco designer. The objects, which range from single small items to heaped-up collections, are artfully presented in layouts that depend on white space for their impact.

Cut out shapes are arranged on white paper, while collages are set on white backgrounds. Ribbons of type complete the look, while varnish gives the colorful photos greater depth and contrast.

FROM THE DESK OF 25 SAN FRANCISCO DESIGNERS

This promo's white cover, its design all type and white paper, hides a colorful interior jammed with beautifully reproduced photographs. The velvety white cover paper helps create a classic, restful look.

GRAPHIC AND RETAIL DESIGN.

HE CREATED A HYBRID STUDIO.

> HIS ENVIRONMENTAL GRAPHICS WIN HIM INTERNATIONAL FAME.

THIS ITALIAN AMERICAN RECEIVED HIS "JUST DESSERTS". >

LETTERPRESS HAS ONE HIS HEART.

SHE IS A FORMER PARTNER OF SBG.

HIS LOGOS GRACE THE GOLDEN GATE NATIONAL PARKS. >

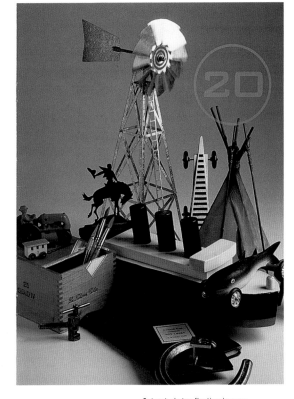

Cut-out photos floating in pure
white space alternate with collages
photographed on white backgrounds.
Designers are renowned for collecting
doodads; Bob Esparza's photos
make the objects seem significant
and inspiring.

Allianz Risk Transfer 1998

The annual report's white board cover
hides a wire binding. The title page
introduces the book's spare, modern style
and its emphasis on art photography.

art director > Achim Booth
designer > Achim Booth
illustrator > Michael Holst
production > Zeros and Ones
client > Allianz Risk Transfer
client's business > Reinsurance
printer > team-Druck
paper > Switzerland 3000
printing > Offset
size > 10 3/8" x 10 6/8" (27 cm x 28 cm)

>>Fine photography is the focus of this annual report for a reinsurance company. Reinsurance, or insurance for insurance companies, is one of the most difficult financial industries to represent visually. Artistic photographs, reproduced as duotones and tritones, give the report a high-end, abstract look and interpret the company's acronym, ART.

"White paper is the classic and most elegant way to present artistic photography," says art director Achim Booth. "We used special metallic inks to give just a hint of color. The white space surrounding the text and photos give an elegant impression of the client."

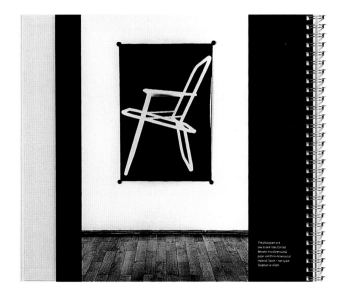

The book's distinctive square shape, thick paper, and special folds give it a weighty, important feel. Metallic inks add interest when used independently and help create exceptional duotones and tritones.

Heidi Gilmore Letterhead
Becker Design

art director > Neil Becker
designer > Neil Becker
client > Heidi Gilmore
client's business > Custom clothing design
printer > Exacta Graphics
paper > Classic Crest Avon
Brilliant White, 24#
colors > One
printing > Offset
size > 8 ½" x 11" (22 cm x 28 cm)
(letterhead), #10 envelope,
3 ½" x 1 ¾" (9 cm x 4 cm)
(business card)
print run > 1,000

>> The client, an upscale clothing designer, needed an upscale letterhead. Black and white, while inexpensive to produce, has a classic elegance like that often found in black and white fashions. By framing the white space with type, the designers created a space that showcases the typed or handwritten text. The large logo "falling" off the page is another stylish touch frequently found on upscale designs.

This simple type treatment, with its elegant vertical strip and "off-the-shoulder" logo, is both upscale and stylish. The business card is narrower than usual for a subtle but distinctive touch.

creative director >	Steve Liska, Liska and Associates Chicago
designer >	Susanna Barrett, Liska and Associates New York
copywriters >	Steve Liska, Liska and Associates Chicago; Susanna Barrett and Mark Naden, Liska and Associates New York
client >	American Institute of Graphic Arts
paper >	Various
colors >	Two

>> Designed to be used in architecture and interior design magazines, which usually feature many large color photographs, these ads use white space to draw attention to themselves. Short copy inviting other design professionals to work with graphic designers frames a blank white page, looking much like a letterhead design.

The minimalist design was inspired by necessity. "We did not have the budget to support the use of photography or illustration," say the designers. "The design was dependent upon a strong text layout and the effect of dramatic white space."

With no budget for photography or illustration, designers used type and white space to create arresting ads that contrast with busy magazine pages. One splash of red reinforces the client's name.

Morris James and Hitchens Brochure
Greenfield/Belser

art director > Burkey Belser
designer > Chris Paul
client > Morris James and Hitchens
client's business > Law firm
colors > Four-color process plus varnish
printing > Offset
size > 6 3/4" x 11" (17 cm x 28 cm)

>> "White space is literally half the Morris James brochure," says designer Burkey Belser. "It creates a definite figure-ground play in the design, which the white brings forth as no other color could." The brochure, aimed at out-of-state companies needing legal help in the client's home state of Delaware, tells the sad stories of ten companies that did not use Delaware-based lawyers.

Each case is illustrated with an oversized number in black ink and a full-color illustration representing an error or slip-up. Black copy, punctuated by key words in red small caps, tells the tales. All elements are showcased in generous white space, which gives them visual prominence and emphasizes their importance to clients.

The cover of this legal brochure uses white space to emphasize its design elements: the large number, the concise title, the illustration, and the client's name. White space helps deliver the desired message quickly and emphatically.

10

SLIPUPS out-of-state lawyers
can avoid with Delaware counsel

Morris James
DEL**AWARE**

Matching advertisements continue the
theme. While the numbers and illustra-
tions take up more of the design area,
white space is still the key to the
design.

3

A publicly traded corporation encountered
FINANCIAL DIFFICULTIES. After much negoti-
ation, all but one of its creditors agreed
to an out-of-court **REORGANIZATION** under
which they would receive 75 cents on the
dollar. Unfortunately, the corporation's
certificate of incorporation had been incor-
rectly drafted and did not include the
Delaware provision that would have made
the informal reorganization **BINDING** on all
the creditors. As a result, the corporation
had to pay the hold-out creditor $500,000
more than it otherwise would have.

Morris James
DEL**AWARE**

4

The directors of a corporation were
presented with an outstanding **BUSINESS
OPPORTUNITY.** Although the corporation
had significant assets, it lacked the cash
to take the opportunity. The directors
decided to take the opportunity for them-
selves. Ten years later, a Delaware court
held that, if the corporation's assets could
have **COLLATERALIZED** a loan, the directors
were required to borrow against the assets
and give the corporation the business
opportunity. The directors were required to
REPAY the $2 million in profits they had
received over the years.

Morris James
DEL**AWARE**

Inside, white space organizes and
presents the text and illustrations in a
style at once corporate and innovative.
Computer-generated shadows and spot
gloss varnish help the illustrations
stand out.

Tharp Did It

design > Tharp Did It with Chris Berner
illustrator > Don Weller
client > The Design Conference That Just Happens to Be in Park City
printer > Heritage Printing Press
paper > Fox River Starwhite Vicksburg Tiara 65 lb. Cover
colors > Two
printing > Offset
size > 35 ¼" x 9" (89.5 cm x 23 cm)

>> A classic example of type and white space, with a contemporary illustration giving it a surprising twist, this mailing for an annual design and skiing conference doubles as a poster. The roman type is arranged in a solid rectangle, careful layout making it readable and humorous copywriting making it enjoyable.

Humor is always evident in materials for The Design Conference That Just Happens to Be in Park City. Here the playful illustration gives the type layout a new context. "The perspective (from above, as from a chair lift) makes the unprinted background read as snow," explains designer Mr. Tharp.

As if you really need 99 reasons to attend The Design Conference That Just Happens To Be In Park City, (your last conference of the Millennium) here they are for those of you who need them. 1. The setting is Park City, Utah, a historic mining-town-turned-ski-resort. 2. It's high in the beautiful Wasatch mountains. 3. Lanny Sommese will be coming all the way from Pennsylvania to speak. 4. He and his wife have their own design firm, Sommese Design, (clever name). 5. They specialize in corporate print communication, packaging, and poster design. 6. Lanny's posters were awarded first prize in the International Biennial of Poster of Mexico in 1994 and in the Triennial of Stage Poster in Sofia in 1995. 7. He is a fellow of the Institute of the Arts and Humanistic Studies at Penn State where he is also head of the Graphic Design Department. 8. The Library of Congress has more than 99 of his posters in its collection. 9. He's one heck of an entertaining speaker. 10. Lana Rigsby will be coming from Houston to speak. 11. She was recently named Adweek's Southwest Creative All-Star Designer. 12. Her design firm's work is included in the Smithsonian Institution National Design Museum's permanent collection. 13. Her work has been recognized in major design competitions and publications including Graphis, Communication Arts, the Mead Annual Report Show, and The AIGA Annual. 14. We've been wanting her to come to Park City for many years, but she says she doesn't ski. 15. This year she'll try. 16. Billy Pittard is coming from Los Angeles. 17. He's considered one of the founding fathers of electronic graphic design for the screen. 18. He began his career in Nashville, moved on to Manager of Design at KCBS TV in Los Angeles, and two years later co-founded Pittard Sullivan, a multinational design firm that combines art and technology for the television, film, print, and convergent media industries. 19. From his Emmy-winning titles for ER to Cutthroat Island, from the world of Disney to Waterworld, from Cyrus to The Food Network, he's done it all. 20. He will blow you away with his presentation. 21. Marty Neumeier, editor and designer of Critique magazine, is coming. 22. He attended Art Center College of Design and began his career as a general practitioner in advertising and design in 1973 when he founded the Neumeier Design Team. 23. He has won hundreds of awards and has been profiled in Communication Arts, Print, HOW, and ID magazines. 24. He will present "Six Predictions for the New Millennium." 25. We promise this will be the last time we use the "M" word. 26. Barbara Kuhr of Wired magazine will also be talking about the next century. 27. She's the better half of Plunkett & Kuhr, the design duo that's been spending its stuff all over the planet for clients from The Sundance Film Festival to The Louvre and a few in between. 28. She'll be coming all the way from Park City. 29. Big skier and illustrator Boris Lyubner will be coming from Park City also. 30. He graduated from St. Petersburg Academy of Arts seventy-five years after Marc Chagall failed his entrance exam to the same school because of his sloppy drawing style. 31. Boris will tell you about his escape from the USSR and his later escape from San Francisco with his wife, two daughters, and Petrusha his parrot. 32. Between skiing, biking, and mushroom hunting he finds time to do some corporate artwork. 33. Terry Slaughter is being shipped in from Birmingham to enlighten you. 34. SlaughterHanson & Associates builds brands through the use of advertising, design, and whatever other communications tools they can get their hands on. 35. The firm was featured in the March/April 1992 issue of Communication Arts and has earned recognition from Print, Graphis, and numerous art direction annuals. 36. Terry is chief steward of the firm's brand, culture, and creative product. 37. One of this conference's past speakers told us, "Terry has been known to bring clients to tears of endearment during his presentations." 38. Bring your hankies. 39. The conference starts Friday, February 6, with registration and the Fox River Paper Company-hosted reception at the Olympia Park Hotel. 40. On Saturday and Monday, we confer in the mornings at 8:30 and break at 11:30. 41. Chris Berner and Petrula Vrontikis will again be your M.C.s. 42. Mr. Tharp and Mr. Ingalls may, or may not, do the traditional warm-up talk before our first speaker. 43. We break for about nine hours, then we reconvene at 8:30p.m. 44. Student Portfolio Morning is Sunday then the rest of the day is open for shopping or more skiing. 45. Most conferees ski Deer Valley Resort and attend the banquet and dance that night at Deer Valley's Snowpark Lodge. 46. The conference ends after the morning session on Tuesday, allowing you time to get back to whatever it is you do between conferences. 47. You'll have easy access and discounted tickets to two ski resorts, Park City Mountain Resort and Deer Valley Resort, all piled high with the greatest snow on earth. 48. The conference will again be held at the Olympia Park Hotel. 49. Most of the conferees will stay right there, so you'll be jade-nobbin' with famous folks as well as the near-icons, like Phil Hollenbeck and Tom Lout. 50. The conference band at the banquet will, of course, be The Fabulous Fuzztones. 51. Pat Foss, Gary Gibson, Tom Lout, Bryan Peterson, Scott Ray, and Chris Rovillo are once again brought to you by the generosity of Heritage Press, where your printing is never fuzzy. 52. "The Fuzzballs", as they are affectionately called by Cha Cha Weller, have kicked most of their bad habits. 53. Speaking of bad habits, there is no guarantee that some big guy from San Francisco won't sit in with them. 54. But come anyway. 55. Kip Henrie will again be your personal ski instructor and counselor. 56. He will help the beginners get started on the first ski afternoon (Saturday), then do whatever the others want to from them on. 57. Between runs he works as a designer at Haddleston Malone Design in Salt Lake City, which qualifies him to listen to both your design problems as well as your ski problems. 58. The experimental Data Blitzes will be continued again this year, but only if Valerie and Forrest Richardson give their official approval. 59. You have something to share with other conferees. 60. Something of human interest, a hobby, a bit of wisdom, or just a little entertainment. 61. Call Forrest at 602.266.6983, a few weeks prior to the conference, with your Data Blitz idea. 62. Slides are the best visuals. 63. But remember, Don Weller is cutting home performers for two and a half minutes and cuts two cows before it's over. 64. And, that's the time we allow no matter how good your stuff is. 65. Forrest says, "No, (absolutely no) rehearsed presentations will be allowed." 66. Illustrator Robert Kopecky may do an edited version of his comedy routine this year if everyone promises to not step on his "mike cord." 67. TFRPCSPC/TDC (The Fox River Paper Company Student Poster Competition That Just Happens To Be At The Design Conference) will happen again. 68. Student attendees enter work, all conferees judge the work, and winners receive First, Second, and Third Place awards and lift tickets. 69. It's that simple. 70. All posters submitted will be on display at the conference. 71. If you're a student and plan to attend contact Stephen Ludwig at 310.796.0556 for an entry form. 72. Or you can request one by e-mail at swludwig@earthlink.net. 73. Attendees are encouraged to review student portfolios on Sunday morning and listen in on Wayne Hunt's topical and intellectual round table discussion with Pat Epstein, Mike Moser, and Valerie Richardson. 74. Petrula Vrontikis will again lead TOYSTJHTBAS (The Official Yoga Session That Just Happens To Be After Skiing). 75. Your personal invitation will be included in your registration packet. 76. Your registration packet will also be full of really cool stuff like Critique magazine. 77. And Wired magazine. 78. And Fox River Paper swatchbooks. 79. And, of course, the Official TDCTJHTBIPC99 Collectors Edition Negative. 80. This year the negators are vintage dated. 81. The registration deadline is January 29. 82. But attendance is limited to 150, so there are no guarantees there will be openings after the December 11 pre-registration deadline. 83. Professionals may take a $20 discount and an immediate 1998 tax deduction if you pre-register by December 11. 84. To simplify things and save money, you can pay for your lift tickets and banquet passes with your registration. 85. Park City half-day lift passes for Saturday and Monday are advance discounted, assuming we meet a group minimum of twenty-five people per day. 86. Deer Valley half-day lift passes are available until Saturday night only, and are also discounted if we sign twenty-five people in advance. 87. Tickets for Sunday's banquet at Deer Valley Lodge cost the same no matter when you purchase them. 88. Everyone is invited to hear The Fuzztones and dance the night away after the Sunday dinner and after the usual giveaways and awards ceremony, and whatever else we're in the mood to do. 89. Transportation is easy from the Salt Lake City International Airport. 90. Van service is available each hour or more frequently, or you can rent a car. 91. The drive from the airport to the conference center is only thirty-six miles. 92. Airfare, lodging (Olympia Park Hotel, condos, or homes), and transportation can be arranged by calling your Official Travel Agent Elizabeth Brown at 800.313.2295 at E.B. Ski Tours. 93. If you have conference questions call Laura Jones at Event Design at 435.289.4541. 94. Call Mr. Tharp at 408.354.6726 only if you have an incredibly brilliant question. 95. Don't miss this conference because it will be the last one of this Millennium, (sorry, we couldn't resist using that word just one last time). 96. You can bring your camera and sketchbook. 97. You can bring your skis and long johns. 98. No laptops, cell phones, or palm pilots allowed... and the 99th best reason to attend T D C T J H T B I P C 9 9 : Because you can.

Although this brochure/poster for a design and ski conference looks like a classic example of type arranged formally on white space, a second glance tells a different story. The two-color illustration transforms the scene from flat type on a white ground to a skycam depiction of skiers swooshing down a white slope dotted with pine trees.

Design Online Letterhead
David Lemley Design

art director > David Lemley
designers > David Lemley, Emma Wilson
client > Design Online LLC
client's business > Online portal for designers
printer > Various
paper > Cougar Opaque
colors > Four-color process
printing > Offset
size > 8" x 10" (20 cm x 25 cm)
print run > 6,000 total

>>Bright white paper sets off the vibrant inks and humorous illustrations used for this letterhead package. Created to appeal to graphic designers, the printed pieces recall computer graphics with a series of tiny designs based on computer icons. Clean white space features prominently in both print pieces for the web-based company, and its web design.

"This project was tons of fun, because as designers we could actually say, 'Hey, man, we are the product demo!' and get taken seriously," says designer David Lemley.

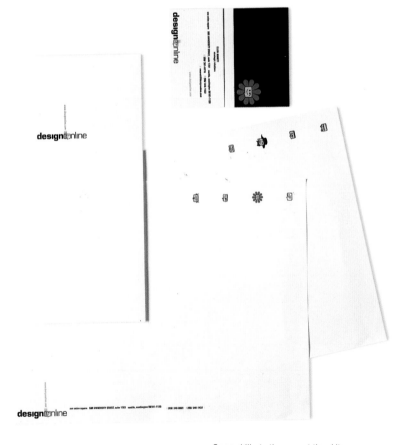

Type and illustrations accent the white paper that's the focus of this letterhead system for a web-based company offering products, news, and discussion forums to graphic designers. Designers loosened up a bit on the two-sided business cards, where color and type feature prominently.

UpSouth
Weaver Design

art director > Marie Weaver
designer > Marie Weaver
photographer > Lee Isaacs
copywriters > Emma Amos, Bell Hooks,
Antoinette Spanos Nordan,
Priscilla Hancock Cooper
event organizers > Anne Arrasmith, Peter Prinz,
Antoinette Spanos Nordan
client > Space One Eleven, Visual Arts
Gallery at the University of
Alabama at Birmingham
client's business > Art galleries
printer > Birmingham Printing and
Publishing
paper > Porcelain Dull 100# text and cover
(book); Ultra UV 34# (fly sheets);
colors > Four-color process
plus flood varnish
printing > Offset
size > 8" x 10" (20 cm x 25 cm)
print run > 1,500

>> A catalog accompanying a citywide exhibition by eleven Southern artists, this book uses a grid featuring extensive white space to unify and organize material from artists with very different styles. "Wide margins have been used for centuries to keep the reader from feeling overwhelmed and to lend an air of luxury," says designer Marie Weaver, whose artwork was also featured in the exhibit. "The white front cover is a bit mysterious by virtue of its minimalism— the South is also a bit mysterious to many people who live elsewhere! The cover is mean to speak of elegance and sophistication, to imply subtle enterprise, and to refer to growth as well as rootedness."

The catalog's white front cover recalls names etched on a gallery door, says designer Marie Weaver. The colorful back cover gives viewers a glimpse through that door. Each strip represents the work of one artist and is arranged in the same order as the artists' names. Flood varnish gives the thick paper extra weight, both visually and literally.

A grid featuring roomy white space organizes ribbons of text, black and white artist photos, and color photos of artwork. Because the catalogue's elegant look was important to the event, the budget included room for generous white space, and the editor limited the copy length to allow for it.

505 Union Station Marketing Brochure
Michael Courtney Design

art director > Michael Courtney
designer > Michael Courtney
illustrator > William Hook
photographer > Latona Productions
copywriter > The Frause Group
client > Vulcan Northwest
client's business > Developer
printer > The Copy Co.
colors > Four-color process
printing > Offset
size > 9" x 12" (23 x 30 cm) (folder)
 8 ½" x 11" (22 x 28 cm) (inserts)

>>The angled white pages inside this brochure for space in a dramatic new building contrast with and emphasize the metallic silver cover. They also emulate the building's architecture, which features a distinctive angled wall.

Custom die cuts on the cover and insert, and a built-in pocket for marketing sheets, contribute to the piece's mystique. The velvety white paper conveys elegance and luxury. "White also provides a neutral background for the four-color printing," says designer Michael Courtney.

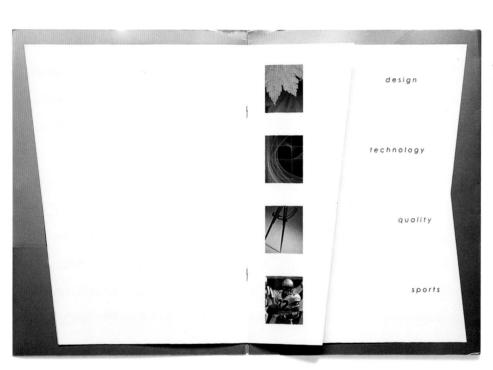

The knocked-out white logo and hairline rule around the four-color rendering give graphic punch to this two-tone metallic silver folder. The custom die-cut edge and closure add a further high-end touch.

Inside, white pages seem to leap off the silver cover. The dynamic angled pages add visual interest and echo the building's distinctive angled front wall. A pocket holds 8" x 10" (20 cm x 25 cm). marketing sheets, printed in black and lush pastels that glow on the velvety white paper.

Lionel Heritage Train Catalog, 1999
Michael Stanard, Inc.

art director > Michael Stanard
designer > Mark Fuhrman
photographer > Dale Debolt
copywriter > Gary Moreau
client > Lionel Trains
client's business > Toy trains
printer > Sells Printing
colors > Four-color process plus spot blue and varnish
printing > Direct-to-plate offset
size > 8 ¼" x 11" (22 cm x 28 cm)
print run > 100,000

>> White space makes this catalog for Lionel's highest-quality toy trains stand out from its mass-market catalogs. The crisp white cover and extensive use of white space throughout the piece showcases distinctive photography that gives the trains an appropriately legendary look.

False duotone backgrounds and computer manipulation of the product photos convey the look of black and white printing with spot color overprinting. The Art Deco-inspired style suits the expensive collectible toys and matches Lionel's retro graphics.

The catalog for Lionel's Heritage line of toy trains stands out from other Lionel publications because of its cool white cover. Panoramic landscape shots reproduced as false duotones represent train travel without showing a single train. Lionel's distinctive logo reads prominently.

This centerfold for a premium toy passenger train emphasizes its length and quality. The background photo makes the train look full size, while computer manipulation of the product photo gives it a surreal look. White space adds to the graphic style, while white type knocked out of the blue bar gives the impression of an additional color.

Entek Brochure
VIA, Inc.

art director > Oscar Fernández
designer > Andreas Kranz
photographer > Ted Rice
production > Shelly Pomponio
client > Entek IRD International Corp.
client's business > Machinery manufacturing
printer > Byrum Litho
colors > Four-color process plus two match
printing > Offset
size > 8 ½" x 11" (22 cm x 28 cm)
print run > 10,000

>> This marketing brochure for an equipment manufacturer communicated many positive changes, including a new business emphasis, with a radical departure from its previous design. Rather than a cluttered "machinery" look, the brochure sports an open, organized feel. Prominent shots of people at work show the company's new commitment to helping people rather than simply making products.

White space provides the backbone of the look. It contrasts with vibrant, full-bleed photos, serves as a neutral ground for blocks of text and tiny photos, and even provides an additional color when knocked out of solid silver pages. Metallic silver, used for backgrounds, text, and small accent squares, adds an elegant touch that recalls metal for manufacturing, wiring for electronics, and even (on one spread) silver pencil bands representing design and training.

The cover of this brochure makes an impact with its unusual (for the client) uncluttered look and its portrait of a smiling worker, which represents a new commitment to customer service. The unusual colors, particularly the metallic silver, and the grid of squares set the stage for the design. The tagline ghosted out of the image establishes white's importance to the look.

You choose tools to ensure the health of equipment and the profitability of your operations. We offer people and systems (software and hardware) for you to select.

tools:

White pages balance with vivid, full-bleed photos, creating a restful balance. Small blocks of text and small square photos float on the velvety white paper in an easy-to-follow format.

Silver appears throughout for text, accent squares, and even solid pages. White text knocked out of the silver background is more readable and attractive than a printed color.

emonitor odyssey condition monitoring
enshare enterprise asset health

automated analysis tools
visualize data from many sources
integrate systems across internet

software

hardware

portable
 hand held data collectors & analyzers
 oil analysis

surveillance
 permanently mounted sensors
 online condition monitoring systems
 simple operator displays
 ethernet & internet operation

protection
 continuous monitoring & protection
 systems
 flexible configuration
 handle high speed & transient needs
 monitor associated process parameters
 shut machinery down to avoid damage

Precustom Dressette Product Pieces
Widmeyer Design

art director > Ken Widmeyer
designer > Carrie Ferguson
photographer > Don Mason
client > Northwest Podiatric
Laboratory, Inc.
client's business > Orthotic shoe inserts
printer > GAC/The Allied Printers
paper > Signature Gloss Text and Cover
colors > Four-color process plus flood
varnish
printing > Offset
size > 2 ¾" x 4 ¼" (7 cm x 10.5 cm)
(flyer); 8 ½" x 5 ½"
(22 cm x14 cm) (postcard)
print run > 10,000

>>Marketing orthotic shoe inserts to women who love fashion may seem like a difficult design task. Designers used white space, type, and tiny product shots to mimic high-fashion ads, hoping to convince women that they could walk in both style and comfort.

"Interestingly, women who wear high heels account for more than 85% of the podiatry market," say the designers. The two print pieces target different audiences—the postcard is aimed at podiatrists and retailers, the tiny brochure at customers—but share the same elegant sensibility. Clean white space highlights the product shots, while white copy knocked out of colored boxes adds the look of another color.

Two advertising pieces for women's orthotic shoe inserts mimic high-fashion advertisements. Extensive use of white space, spare and elegant type, and small, product-only photos give the advertisements for eminently practical products a haute-couture look.

800.443.7260
www.nwpodiatric.com

Northwest Podiatric Laboratory, Inc.

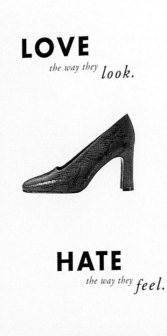

LOVE *the way they* *look.*

HATE *the way they* *feel.*

FASHION *doesn't have to be* *painful.*

50% OF NORTH AMERICAN

WOMEN WEAR HIGH HEELS

DAILY AND MOST SUFFER FROM

ACHES, PAIN AND FATIGUE.

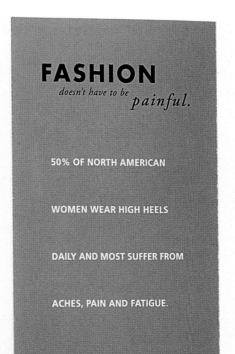

The PreCustom® Dressette® with its

exclusive Internal Balance System™

reduce or eliminate these symptom

FASHION *should be* *comfortab*

Ovation Wine Label
Auston Design Group

art director >	Tony Auston
designers >	Eric Spellman, Tony Auston
illustrator >	Tony Auston
photography >	David Bishop
client >	Joseph Phelps: Ovation
client's business >	Winery
printer >	Ben Franklin Press
paper >	Simpson Estate #8
colors >	One
printing >	Offset
size >	4 ¾" x 3 ⅜" (12 cm x 9 cm)

>>A digitally manipulated photograph of a grapevine tendril is the main design element in this distinctive wine label. A thick black bar along the bottom edge identifies the year the wine was made, and gives the label definition. Another black line neatly divides the white space a third of the way down, giving it classical dimensions. The stylized grape vine winding around it recalls the diagrams of musical vibrations used vividly in Disney's *Fantasia*, a fitting image for the musically named wine.

White labels stand out in a crowded wine shop or grocery store, where more and more wines are offered. "The use of white space helps create an upscale, contemporary, minimalist image for the brand," says designer Tony Auston. "Less is more."

A spare white label with distinctive, minimal graphics gives this wine an upscale look. White space creates the perfect background for the digitally manipulated photo of a grapevine, an abstract image that suggests music as well as wine.

Boullioun Aviation Services Brochure
Hornall Anderson Design Works

art director >	Jack Anderson
designers >	Kathy Dalton, Belinda Bowling, Ryan Wilkerson
photographers >	Boeing, West Stock, Tony Stone, Alan Abramowitz
copywriter >	John Koval
client >	Boullioun Aviation Services
client's business >	Aircraft leasing
printer >	Color Graphics
paper >	McCoy, Strathmore
colors >	Eight plus
printing >	Offset, engraved, stamped

>> This lavish package repositioned the client, one of the world's top aircraft leasers, after an identity redesign. Engraving, foil stamping, die cutting, and other specialty print techniques, including a Smith sewn binding, all demonstrate wealth, discernment, and appreciation for fine things. Even before they look at the weighty package's contents, corporate recipients know that Boullioun shares their values.

The white cover, elegant and understated, sets the tone for the package with its textured paper, debossing, and applied metal cut-out. Inside, white pages contrast with glossy four-color printing to present vital information about the company.

The textured white paper on the covers is debossed and decorated with an applied metal cut-out. The French-folded pages are sewn together, and an applied four-color binding gives a hint of color.

Inside, a saturated four-color photograph is die-cut to reveal a piece of glossy white paper, tipped in, and a matte white page. The "unnecessary" white papers add a feel of luxury and attention to detail.

A map of the world, embossed on both sides of a white French-folded page, shows the company's locations. The matte white paper contrasts with the glossy, vivid four-color printing throughout the brochure.

Sterling Design Letterhead and Promo
Sterling Design

art director > Jennifer Sterling
designer > Jennifer Sterling
illustrator > Jennifer Sterling
photographers > John Casado, Dave Magnusson
lettering > Jennifer Sterling
client > Self
printer > Logos Graphics
colors > One (letterhead); four-color
process (booklet)
printing > Offset, embossing
size > Standard U.S. (letterhead);
5 ¹/₂" x 8 ¹/₂" (14 cm x 22 cm)
(booklet)

>> Designer Jennifer Sterling made the most of her distinctive style in these business pieces. Arrangements of type and shapes reminiscent of antique mechanical drawings, extensive use of white space, vellum papers, embossing, and metal all figure prominently in her work and in this business stationery and promo.

Blind embossing, stamped and perforated metal, and nearly all-white paper sheets mark the stationery set, which features a metal business card and custom round metal clips. The promo book, its die-cut pages screwed onto a brushed-aluminum plate with a silver fastener, contrasts vellum pages printed in black ink with four-color photos of the designer's work.

Designer Jennifer Sterling specializes in distinctive "diagrams" printed in black on white paper, often with embossing or letterpress elements. This package of business stationery shows off the look, demonstrates its practicality, and includes custom metal pieces—another of the designer's favorites.

Mailed in a silver mesh bag, this portfolio of the studio's work melds the black and white work, the designer's forte, with full-color photos of her projects. White vellum pages contrast with the four-color printing and allow for layered arrangements of type and illustrations. The screw holds the die-cut pages to a brushed aluminum plate, giving clients a demonstration of the designer's fondness for combining metal and paper.

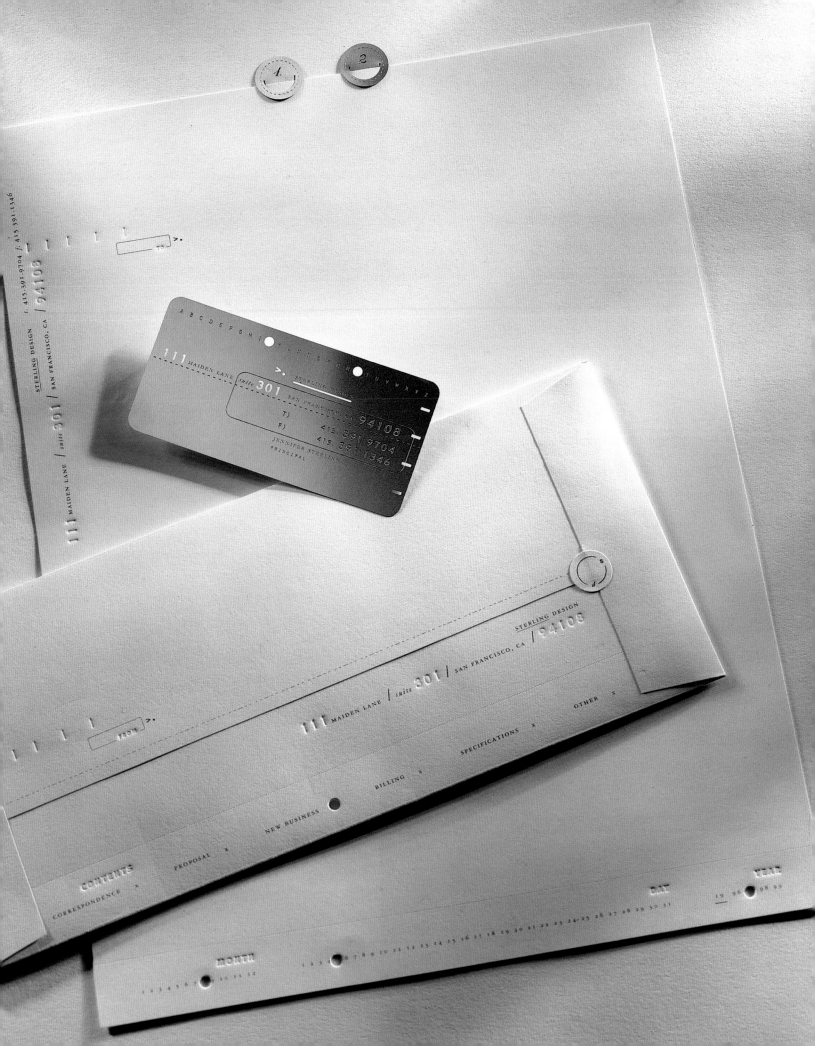

white for impact

>> White space — the absence of color, type, or image — remains an ever-popular design tool. But often the addition of white or the use of white as a color can be equally dramatic.

White as a second (or third or fourth . . .) color can be produced in two opposite ways: by applying white ink, or by revealing or "knocking out" white paper through a colored ink.

Both methods take advantage of the properties of white, its brightness and contrast, to enhance other colors. Both require careful printing and, sometimes, extra cost. Obtaining an opaque white ink on a colored paper may entail a second printing, or "double hit." Getting a good knock-out means precise registration, particularly if more than one printing plate is used. But the results are worth the effort.

A third emphatic use of white is so simple that many designers never think of it. It's simply combining a white sheet or other item with items of saturated color. A plain white paper in a dark folder, a white label on a dark wine bottle, a white wrap around a colored book — all of these examples show how a white item can itself become part of an overall graphic design, not just a canvas to hold it.

Mediatex Letterhead and Folder
The Riordon Design Group, Inc.

art director > Ric Riordon
designer > Greer Hutchison
client > Mediatex
client's business > Promotional products
printer > Somerset Graphics
paper > Classic Crest Solar White
colors > Two
printing > Offset plus embossing
size > 9" x 12" (23 cm x 30 cm)
print run > 1,000

>> An elegant white folder for a company that manufactures corporate promotions draws attention to the letterhead and business card inside. Outside, the folder's smooth white paper creates a cool, uncluttered feel. Inside, solid navy blue and metallic copper ink act as a foil for the heavy textured letterhead paper.

All pieces are embossed, giving them further visual weight. The bright white letterhead stock, with stripes that can be touched as well as seen, communicates the quality and attention to detail important to the client's corporate customers.

Embossing over metallic ink makes the company's logo stand out, literally, from the white paper folder. The company, which manufactures promotional products, promotes itself with quiet confidence.

Inside, solid blue and metallic copper printing make the felted white letterhead and business card leap out. The embossed logo and textured columns in the paper contrast further with the folder's smooth finish.

Take Care of Your Face Shaving Set
Sayles Graphic Design

art director > John Sayles
designer > John Sayles
illustrator > John Sayles
client > Gianna Rose
client's business > Toiletries
printing > Foil stamping

>> Black and white retro graphics and packaging complement one another in this gift set of men's shaving products sold at high-end department stores and boutiques. A black box holds the two face products, which come in white bottles with black caps, and a two-tone shaving brush. Black labels were stamped with a white foil for a luxurious, opaque coverage. The result is a distinctive look that stands out from competitors.

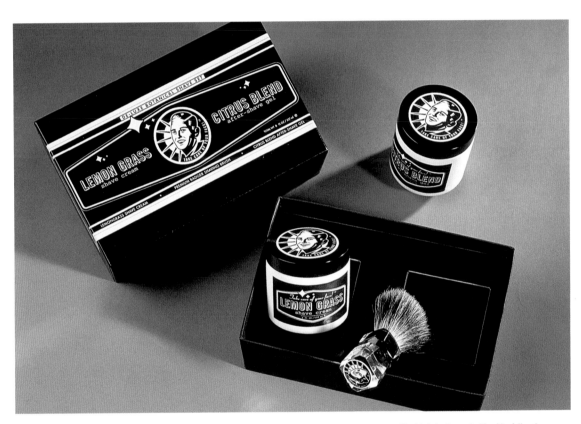

Black labels stamped with white foil and a black gift box help create a retro look. Inside, the white bottle of shaving soap and its black lid, even the two-tone bristles on the shaving brush, complete the distinctive look.

Partners Formula Book
Blok Design

art director > Vanessa Eckstein
designers > Frances Chen, Vanessa Eckstein
photographer > Don Miller
client > The Partners' Film Company
paper > Blueprint paper
colors > One
printing > Diazo
size > 8 ½" x 11" (22 cm x 28 cm)

>> Blueprints, rarely used in books, provide an intriguing look for this book about the directors the client film company represents. "The concept of 'formula book' was enhanced by the blueprints making everything seem like a chemistry exercise," the designers say. "White is both text and context, and the simple mix of light and lack of light creates boldness and clarity."

Diazo printing creates images, literally, with light. Light reflects off drawings or diagrams onto photographic paper, which turns blue and makes a "blue print." (Black diazo printing is a less well-known option.) Generally crisp, it also produces random blotches that the designers made part of the piece's look. It's also inexpensive, especially for small runs. Because this piece needs regular updating, additions and changes are simple and cheap. Pages simply slip into a three-hole binder.

The blotches and fuzzy lines that are part of the blueprint process add to the design and inspire abstract images.

The blueprint process allows text pages to be either blue on white or white on blue.

The title *Formula Book* is reinforced by the blueprints themselves, which give the piece a scientific feel. A mock periodic chart of chemical elements was used throughout to support the chemistry theme.

Victoria's Birth Announcement
Belyea

art director > Patricia Belyea
designer > Patricia Belyea
illustrator > Cary Pillo Lassen
client > Self
paper > Gilbert Oxford, Peach 80# Cover
colors > One plus foil
printer > Impression NW
printing > Offset, foil stamping
size > 5 ½" x 12" (14 cm x 30 cm)
print run > 350

>> Designers frequently tend toward graphic exuberance when creating birth announcements for their children. Patricia Belyea, however, chose an understated approach. She selected a soft peach paper and coral ink to represent the baby's sex. The major design element, a giant capital V, received the same muted touch. Rather than specifying bright ink, Belyea had the letter foil-stamped in white to deliver a distinctive, feminine impression.

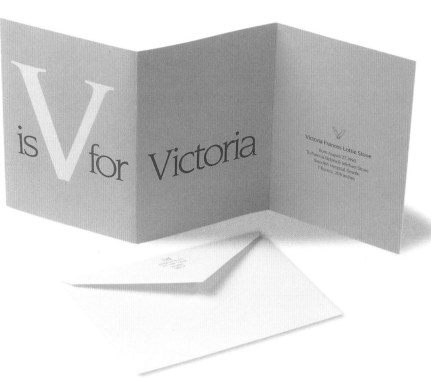

The white, foil-stamped *V* is the dominant element of this simple but elegant accordion-folded announcement. The glossy foil and stamped impression help the white stand out from the colored, textured paper.

fourthchannel
VIA, Inc.

art director > Oscar Fernández
designer > Andreas Kranz
photographer > Ted Rice
production > Shelly Pomponio
copywriter > Wendie Wulff
client > fourthchannel, inc.
client's business > Web catalogs
printer > Superior Printing
paper > Crawford Poly, Glama
colors > Three
printing > Offset
size > 7" x 7" (18 cm x 18 cm)
print run > 10,000

>> Clear plastic covers and see-through white pages create a distinctive look for this book introducing a startup web-based company. Text and graphics are printed on one side of the French-folded pages. The thin, translucent paper ensures that readers can see the graphics from the other side of the page as they read, recalling the layers of "pages" in Internet commerce.

"The brochure breathes white space by the abundant use of translucent papers and plastic," says designer Oscar Fernández. "White is further heightened through show-through letters." The slick white paper also steps up the three bright ink colors, giving the piece further visual impact.

The brochure's clear plastic cover, printed with blue boxes and a digitized photo in blue and orange, allows readers to see the paper beneath it. The cover design works both independently and with the design printed on the white paper beneath it, creating a layered message.

The layered graphics continue throughout the book. Graphics on the facing sides of the translucent white French-folded pages are visible through each spread. The bright inks appear even brighter on the slick paper stock.

Madison Lucille Plunkert's
Tiny Book o' Fun Facts
Spur

art director >	David Plunkert
designer >	David Plunkert
copywriter >	David Plunkert
photographer >	Joyce Hesselberth
client >	Midson Plunkert
client's business >	Infancy
printer >	London Litho
paper >	Hammermill 80# Linen Cover
colors >	Two
printing >	Offset
size >	4" x 5 ¼" (10 cm x 13.5 cm)
print run >	400

>> To announce the birth of their baby, designer David Plunkert and his wife created an eight-page "book o' fun facts" filled with humorous illustrations about labor and birth. The two-color book ("PMS Black and Baby Poop 118") uses the revealed white paper as a vibrant third color.

"The linen paper stock suggests a soft white fabric" appropriate to a new baby, Plunkert says, and denotes innocence and purity. The announcement's illustrations and copy, however, share a wry adult sensibility all parents can share.

Factual information is presented in beautiful, spare type, floating on a soft white paper reminiscent of fabric. The paper's bright color, like bleached linen, makes it an integral design element. On the black page, a tiny line of white around the photograph makes it stand out.

On the birth announcement's cover, white is both a canvas for design elements and a third "ink" color in the knocked-out title. The irreverent illustration ("Mr. Murray Knobsnocker, baby impersonator and breastfeeding advocate") sets the tone for the rest of the piece.

Madison Lucille Plunkert's

TINY
BOOK O'
FUN FACTS

MR. MURRAY KNOBSNOCKER
Baby impersonator and
breastfeeding advocate

KINETIK Y2K Four-Color Self-Promotion
KINETIK Communication Graphics, Inc.

design team > Jeffrey Fabian, Samuel Shelton,
Scott Rier, Kamomi Solidum,
Beth Clawson, Katie Kroener,
Beverley Hunter, Ali Kooistra
client > Self
printer > Beach Brothers Printing
paper > Mohawk Superfine
colors > Four-color process
printing > Offset, letterpress
size > 5 ½" x 4 ³/₁₆"
(14 cm x 10 cm) (folded)
print run > 750 each of five designs

>>Four-color printing and blind embossing on crisp white paper made this self-promo a memorable and useful gift. Recipients could use the blank greeting cards, mailed with five blank envelopes, to write correspondence. Short copy urged them to "make connections without a modem."

Each of the abstract designs represents one of the five senses; blind-embossed words and designs continue the symbolism. The white paper is both beautiful and functional: White space frames the artwork on the outsides of the cards and provides space for writing on the insides.

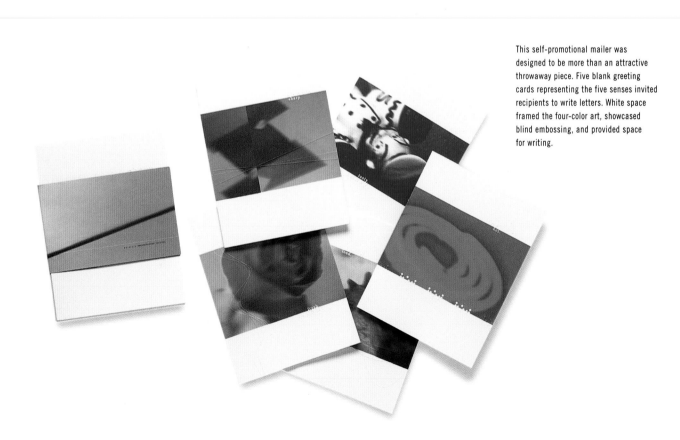

This self-promotional mailer was designed to be more than an attractive throwaway piece. Five blank greeting cards representing the five senses invited recipients to write letters. White space framed the four-color art, showcased blind embossing, and provided space for writing.

Jacknabbit.com Print Package
David Lemley Design

art director > David Lemley
designers > David Lemley, Emma Wilson
client > Jacknabbit.com
client's business > Online appointment scheduling
printer > Emerald City Graphics/Heath
paper > Neenah Classic Crest
colors > 3/1 match
printing > Offset
size > 8 ¹/₂" x 3 ⁵/₈" (22 cm x 9.5 cm) (pad)
print run > 10,000

>> Two-sided printing, layered graphics, humorous illustration, and clever use of white space mark these print pieces for an online appointment scheduling service. White appears as both a background and a third color in the vibrant package, which also features orange, blue, red, and two shades of green.

The first side of each piece features a simple, clean design. Type, the company logo, and a swirling line are pleasingly balanced, and the red dot in the company's name adds small but bright punctuation. The second side, each piece its own bright color (the envelopes were printed before conversion), contrasts with layered graphics and heavy type messages.

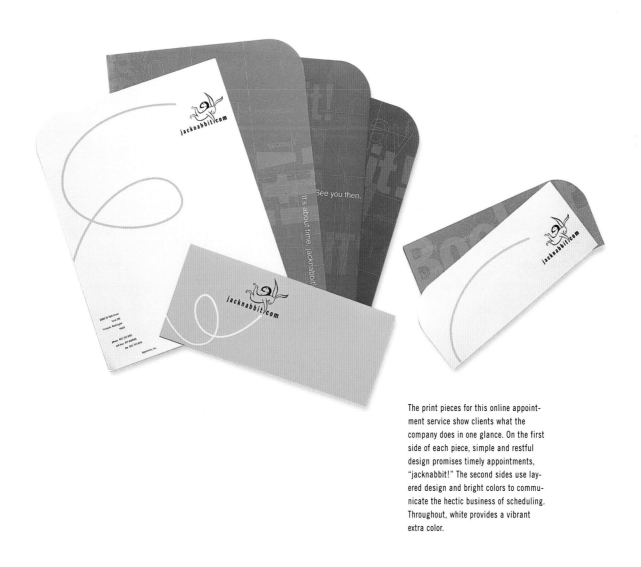

The print pieces for this online appointment service show clients what the company does in one glance. On the first side of each piece, simple and restful design promises timely appointments, "jacknabbit!" The second sides use layered design and bright colors to communicate the hectic business of scheduling. Throughout, white provides a vibrant extra color.

Seattle Architectural Foundation
Business Package
Michael Courtney Design

art director > Michael Courtney
designers > Mike Courtney, Scott Souchock, Dan Hwang
photographers > Ted Grudowski, Tom McMeekin
client > Seattle Architectural Foundation
client's business > Nonprofit foundation
printer > The Copy Company
paper > Neenah Classic Crest, Various
colors > Two
printing > Offset
size > Various
print run > 2,000

>> "Projects with limited budgets still deserve big ideas," says designer Michael Courtney. "We worked with a talented photographer and a great board to get the best design from a challenged budget." Striking architectural photography and a variety of translucent, opaque, and textured white papers give this set of business papers for a nonprofit organization a unique look. The organization's name, printed in sober burgundy, is the only spot of color.

Tiny but striking architectural photographs, reproduced in black, catch the eye in this set of stationery and marketing materials for a nonprofit organization promoting architecture. A variety of white papers, translucent and opaque, add texture and interest.

Seattle Architectural Foundation

1333 5th Ave.

Level 3

Seattle, WA

98101

T (206) 667.9184

F (206) 667.9183

www.seattlearchitectural.org

Seattle Architectural Foundation

1333 5th Ave.

Level 3

Seattle, WA

98101

T (206) 667.9184

F (206) 667.9183

www.seattlearchitectural.org

Seattle Architectural Foundation

1333 5th Ave.

Level 3

Seattle, WA

98101

Robin J. Scott
Executive Director

art director > Vicki Strull
designers > Vicki Strull, Catherine Wells,
Jason Snape
illustrator > Laura Ljungkvist
copywriter > Nicole A. Lillis
client > One World Learning
client's business > Sustainable business conferences
printer > Photographics Communications, Inc.
paper > Crane's Denim (cover);
Fox River Rubicon (text)
colors > Six
printing > Offset plus embossing
size > 6 7/8" x 10 3/16" (17 cm x 25.5 cm)
print run > 1,500

>> This unusual conference book for an unusual company emphasizes creativity and inspiration. Varying page sizes, die cuts, and folds work with bright artwork, layered type, and lots of space in which attendees can write. The unusual binding allows the client to customize pages for each conference.

Although the six-color piece features many pages of saturated color, white is integral to the design. It grounds the colors, creates a light and attractive look, and provides a nonthreatening blank space for attendees to fill with their own ideas and plans. The tree-free paper also reflects the client's dedication to ecology.

White becomes another color in this six-color conference book, softening the bright inks and creating lots of empty space for attendees to write on. The pages, which feature varying sizes, shapes, and folds, can be customized to each conference.

This series of posters designed for urban barricade-style display includes white both as a fifth color punctuationing four match inks and as negative space used to frame crudely reproduced photos. The result is a stylish twist on classic wood-type poster design.

design > Tharp Did It
client > San Jose Film Festival
printer > Pizzazz Printing
colors > Four
printing > Offset
size > 14 ¹/₂" x 19" (37 cm x 48 cm)

>> White becomes a dramatic fifth color in this series of posters for a film festival. "The budget was limited to black plus three match colors," says designer Mr. Rick Tharp. The revealed white space of the paper takes on the look of a match white ink.

White plays a second role as well. The focal number *10* in each poster acts as a frame for photos reproduced through oversized dot screens. "The negative space of the number *10* becomes the window through which the viewer sees filmmakers and actors," Tharp explains. "White space becomes 'positive' and black becomes 'negative' in this urban barricade poster series. Nothing defines something."

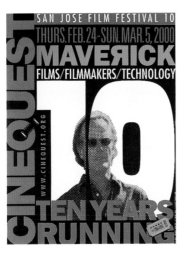 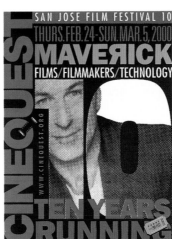 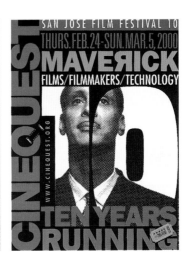

art director > Amy Hawk
copywriter > Bryn Mooth
illustrator > Luba Lukova
client > *HOW* magazine
printer > Quebecor Pendell Printing
paper > 80# Consolidated Centura Cover
colors > Four-color process
printing > Offset
size > 8" x 10 ⁷⁄₈" (20 cm x 28 cm)
print run > 35,000

>> Bulgarian poster designer Luba Lukova, known for her simple graphic style, designed this cover for the annual international design competition issue of *HOW* magazine. Bold use of white and a few dense colors comprise a common theme in her work. The cover illustration demonstrates that the principles of poster design can be equally effective for magazine design. The editor and art director kept to the color scheme for the masthead and teasers. "Effective use of white elements can enable important elements to really pop off the page," says art director Amy Hawk.

Though printed in CMYK, this cover design for *HOW* magazine uses the same design techniques that make classic screenprinted posters effective: bold colors and simple lines. White, knocked out of the saturated illustration, becomes a vibrant fourth color.

Cornerstone Cellars Wine Label
Michael Osborne Design

art director > Michael Osborne
client > Cornerstone Vineyards
client's business > Wine producer
colors > Three
printing > Offset plus embossing

>> Black and gray printing decorate this unusual wine label, but its real impact comes from an off-kilter shape and blind embossing on crisp white paper. Embossed letters in various sizes overlap each other horizontally and vertically. The label's placement repeats the overlapping theme, wrapping around the bottle and itself. "There was an ample budget," says designer Michael Osborne. "That allowed for the relatively expensive multilevel brass die embossing process." The result is "an ultra premium label for a $50 bottle of wine."

The label's unusual shape and seemingly sparse type placement give little indication of its ultimate graphic effect. Printed type in two colors is carefully placed so that it falls mostly on flat spaces between the two-level blind embossing.

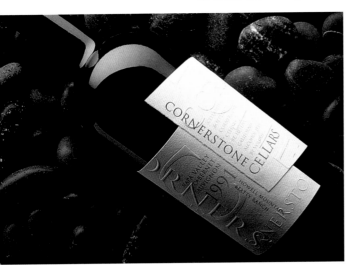

Asymmetrically wrapped around the dark bottle, the white label suddenly becomes a dramatic graphic statement. The printed copy lines up to become a single graphic element, while the blind-embossed letters on crisp white paper become the design emphasis.

Cincinnati Bell Wireless Promotion
Kolar Design

art director > Kelly Kolar
designer > Brent Beck
illustrators > Brent Beck, Lisa Ballard
client > Cincinnati Bell Wireless
client's business > Wireless telephone technology
printer > American Paper
colors > Four-color process plus varnish
printing > Offset
size > 8" x 15" x 4"
(20 cm x 38 cm x 10 cm)
print run > 25,000

>>Challenged to create a holiday shopping bag without any traditional Christmas symbols, Kolar Design used white space to create the look of drifting snow. Although four-color printing offered an almost limitless palette, the designers chose to create a rich, quadratone blue and use the glossy white paper revealed by the design to represent the pure white of snow.

"We could have done it in one color blue," says designer Kelly Kolar, "but we felt we needed the extra values that we could only achieve through four-color printing." Glossy varnish makes the white glow and adds depth to the layered images and numbers.

A pattern of snowflakes and numbers represents the client's business (the numbers on a telephone keypad) and the winter holiday season. Four-color printing helps create a rich, layered look, while varnish emphasizes the glossy white paper stock that represents snow.

New Year's Eve Millennium Special Graphics
KCOP-TV

art director > Mike Sabota
designer > Nancy LeMay
news director > Stephen J. Cohen
copywriters > Natalie Romano, Brian Skelton
client > Self
client's business > Television station

>> To highlight a two-and-a-half hour special program focusing on local New Year's Eve events, KCOP-TV in Los Angeles created cool and elegant accent graphics that avoided graphic clichés. Festive but abstract, the graphics for the station's plasma screen and backgrounds focused on the color white.

"I thought white would carry the design as a symbol of freshness, space, technology, and the newness of the moment," says designer Nancy LeMay. "The use of white for the millennium helps express the feeling of the start of something new, as if time were a sheet of paper, not yet used." Produced in Quantel Paintbox, the graphics were designed and finished in only five days.

Two sets of graphics worked together for the station's coverage of New Year's Eve in Los Angeles and around the world. Graphics for the station's plasma screen, shown here with the anchor, introduced each segment. Bright colors and a festive pattern of circles play off the glowing white backgrounds and letters.

Art used behind the anchors throughout the broadcast relies on its white base and strong typography for impact. An abstract design of circles and fireworks communicates the festive occasion, while white symbolizes new beginnings.

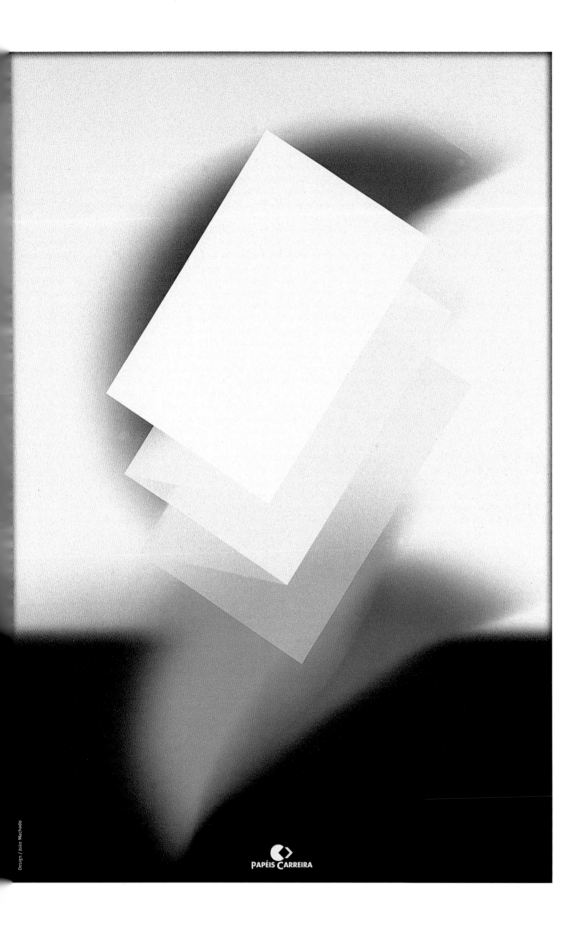

PAPÉIS CARREIRA

Paper Posters
João Machado Design, Lda

art director > João Machado
designer > João Machado
photographer > José Luís Braga
illustrator > João Machado
client > Sociedade de Distribuição de Papel
client's business > Paper company
paper > Tintoretto Neve
colors > Four
printing > Offset
printer > Norprint
size > 27 1/2" x 4 1/2" (70 cm x 11 cm)

>> After ten years of producing promotions for a Portuguese distributor, João Machado knows how to promote paper. His avidly collected annual poster series for the paper company makes sheets of white paper into art objects.

A master of posters—he's done nearly four hundred, and has his own traveling poster exhibit that shows at museums around the world—Machado knows a thing or two about implying dimension on a flat plane. The 1999 series, created around the theme of water, is meant to convey the paper's excellence. The white papers (the distributor's main product) are shown flat, folded, and curled to convey their tactile qualities.

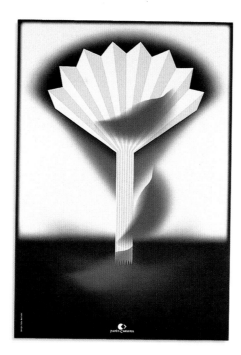 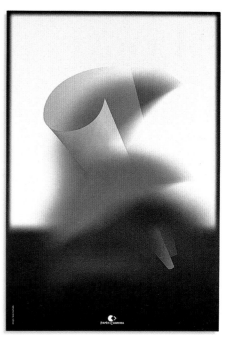

Abstract designs contrast expanses of feathery color, representing water and objects, with white paper. Straight, folded, or rolled, the white paper dominates the designs.

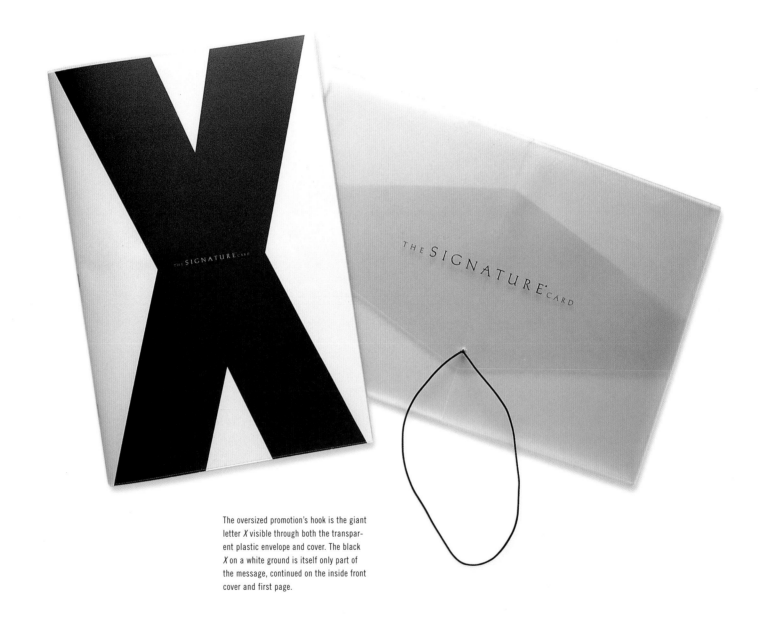

The oversized promotion's hook is the giant letter *X* visible through both the transparent plastic envelope and cover. The black *X* on a white ground is itself only part of the message, continued on the inside front cover and first page.

The Mead Signature Card Promo
Oliver Kuhlmann

art director > Deanna Kuhlmann-Leavitt
designer > Deanna Kuhlmann-Leavitt
photographer > David Gill
copywriter > Stephanie Fedder
client > Mead Coated Papers
client's business > Paper manufacturer
printer > Lithographix
paper > Mead #100 Signature Dull
(text and cover)
colors > 8/8
printing: > UV eight-color offset lithography
size > 10" x 15" (25 cm x 38 cm)
print run > 35,000

>>An oversized promotion introducing a new way of buying paper, this piece for Mead used transparent plastic to enhance its bold design. A plastic envelope and plastic wrapper, both with a pebbled finish to deter fingerprints, show the giant black *X* on the white cover. Opening the cover reveals that the *X* is only part of the "XXL" message that paper buyers can receive frequent buyer benefits from a special credit card.

Inside, the bright white coated paper plays off acid colors and brash illustrations. Gray and white letters on solid black pages explain the incentive program. The package included sign-up kits for recipients to use by email, fax, or post.

Each page is a solid, vivid color punctuated by an image or a small block of text. White plays an important role throughout. On this spread, the white paper revealed in both the illustration and the letters seems to glow against the solid ink.

designer > Martin Yeeles
client > Emerson College
printer > Emerson College
paper > Scheufelen Job Parilux Silk
74# Cover
colors > Two
printing > Offset
size > 8 ¹/₂" x 5 ¹/₂" (22 cm x 14 cm)
print run > 500

>> Limited to a two-color budget, with no money for photography or illustration and working with an unwieldy title, designer Martin Yeeles used white circles on a blue ground to organize this booklet for Emerson College students. The slim pamphlet reprints a story by American Indian writer Sherman Alexie and advertises *Smoke Signals*, the film made from that story.

The white circles symbolize smoke rings and organize the three titles—or the film, the story, and the Emerson College Common Reading and Viewing Experience—into an easy-to-read whole.

White circles provide the visual and organizational key to the cover of this pamphlet for Emerson College students. Symbolizing smoke rings, the circles organize complex information and separate the three titles. Knocked out from the vivid blue ink, the white rings and letters seem to use a vibrant third ink color.

white graphics

Wedding Invitation
Refinery Design Co.

art director > Michael Schmalz
designer > Michael Schmalz
client > Dave and Rena Klavitter
paper > Speckletone
colors > Two
printing > Offset
printer > Union-Hoermann Press
size > 6 ¼" x 4" (15.5 cm x 10 cm)
(folded)
print run > 300

>> A clock illustration provides the focus of this unique wedding invitation, a small bound book. The book, printed in black on white paper, begins with the illustration, which is also printed on several round seals. The text follows on several "pages." The book format stands out from typical wedding invitation style, but the real graphic impact comes from the wrappings: shaped envelopes and a card sleeve.

The unusual, uncoated paper stock chosen for these items infuses color into the otherwise black and white piece. The clock design, printed in white ink, becomes an allover carpet pattern that ties everything together in one stylish package.

The honour of your presence is requested at the marriage of

Rena Sarigianopoulos
and
David Klavitter

White seals on the envelope and invitation carry the same clock illustration that is used for an allover pattern on the thick, colored paper. White ink sinks into the uncoated stock for a distinctive look.

The invitation itself, a "book" bound into a heavy card sleeve, is printed in black on crisp white paper. An enclosed response card matches the envelope and sleeve and is printed in the same carpet pattern.

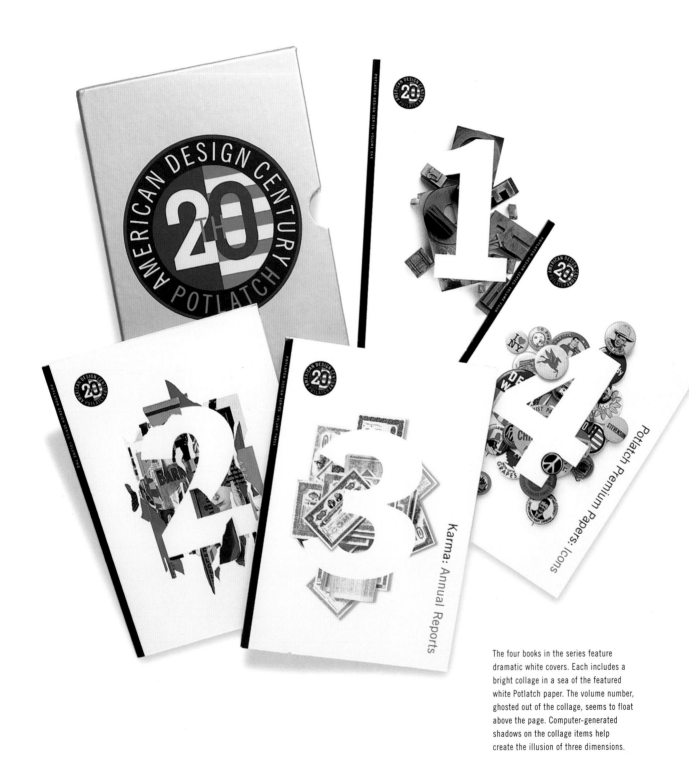

Karma: Annual Reports

Potlatch Premium Papers: Icons

The four books in the series feature dramatic white covers. Each includes a bright collage in a sea of the featured white Potlatch paper. The volume number, ghosted out of the collage, seems to float above the page. Computer-generated shadows on the collage items help create the illusion of three dimensions.

concept >	Pentagram and Hirasuna Editorial
design >	Pentagram/San Francisco
text >	Delphine Hirasuna
cover photographers >	Terry Heffernan (1 and 2), Barry Robinson (3 and 4)
additional photography >	Various
illustrations >	Various
client >	Potlatch Corporation
client's business >	Paper manufacturing
paper >	Potlatch Vintage, McCoy, Karma
colors >	Four-color process with various match inks and varnishes
printing >	Offset
size >	7" x 10" (18 cm x 25 cm)

>>The four books in the American Design Century series do much more than promote Potlatch papers. Put together by one of the country's top design firms, they document the development of typography, poster, icon, and annual report design in the twentieth century. Like most paper promotions, these books boast top-quality production and printing. The fabulous reproduction of art and photography helps the reader to appreciate the original designs.

The covers make use of white space in a unique way, with ghosted numbers appearing to float above bright collages. Inside, a strong grid featuring plentiful white space unites the plethora of featured design styles in each book and connects the four books, which were released one at a time.

Hupp Motor Car Corp. 1938

Puget Sound Power & Light Co. 1944

General Foods 1949

Transamerica Corporation 1950

Xerox 1972

The Ansul Company 1961

Westinghouse Electric 1978

Chase Manhattan Bank 1968

Scovill 1972 Annual Report

1972 WAS A RECORD YEAR FOR SCOVILL. WITH SALES UP 14 PER CENT AND PER-SHARE EARNINGS UP 24 PER CENT OVER 1971. THE MAJOR PART OF THIS IMPROVEMENT CAME FROM GAINS IN OUR CONSUMER RELATED PRODUCT LINES WHICH ACCOUNTED FOR APPROXIMATELY 90 PER CENT OF 1972 EARNINGS COMPARED WITH ONLY 20 PER CENT TEN YEARS AGO.

Scovill Manufacturing Company 1972

National Audubon Society 1995

Litton Industries 1977

Micom Systems Inc. 1983

Woodward's 1985

Adaptec Inc. 1995

Metropolitan Life 1984

Playboy Enterprises 1986

KARMA BRIGHT WHITE 100 LB. TEXT FOUR-COLOR PROCESS, MATCH GREY, SPOT VARNISH

Aetna Life 1921

Robbins Mills 1949

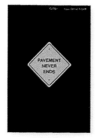

CalMat 1994

Cracker Barrel 1986

Burlington Industries 1965

Herman Miller 1985

Houston Metropolitan 1980

H.J. Heinz Co. 1975

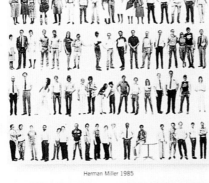

Norlin Corporation 1974

American Can Co. 1968

American Can Co. 1966

CBS 1964

Logicon 1985

Hunt Foods & Industries 1962

Time Warner Inc. 1989

G.D. Searle & Co. 1957

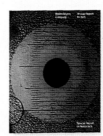

Bristol Meyer 1975

15

Inside, white space helps define and contrasts with the bright designs and photographs that tell the story of graphic design's evolution over the century. Introductory essays and brief captions explain the images. Drop shadows help continue the three-dimensional feel.

art director > Joel Goldfoot
designer > Brian Buckner
photographer > John Sexton
copywriter > Barry Callen
client > Self
printer > Color ink
paper > Various
colors > Six
printing > Offset
size > 8 ¾" x 11 ½"
(22 cm x 29 cm) (folder)
print run > 2,500

>> Red, white, and black work together to create a bold and sophisticated promotion for a firm specializing in marketing, advertising, and public relations. One side of a solid red folder holds a booklet printed in black on a variety of white papers. The other side is a pocket for product sheets featuring small blocks of photos and text printed in color on pure white sheets.

"We wanted to convey strength, confidence, big thinking, and refined taste," says art director Joel Goldfoot. Sophisticated printing and fine papers demonstrate that the firm knows what design tools create the greatest impact — and when to use them.

A solid red folder printed in bold black ink sets the design's tone, which the art director describes as bold and confident. There is nothing lurid about this elegant use of red.

The left side of the folder holds a black and white booklet printed in black on alternating coated and translucent papers. Tiny four-color product images add richness without detracting from the black and white scheme. The right side, an integral pocket, holds product sheets printed in small blocks of type and copy floating on a sophisticated expanse of white.

France '98 World Championship Soccer Poster
R&M Associati Grafici

art directors > Raffaele Fontanella,
Maurizio Di Somma
designers > Raffaele Fontanella,
Maurizio Di Somma
illustrator > Marcello Cesar
client > France '98 World Soccer
Championship Organization
Committee
client's business > Soccer championship
colors > Five match
printing > Offset

>> To represent soccer's global appeal, the designers chose to use the five colors of the Olympic rings in this poster for the France '98 World Soccer Championship. The colored dots making up the background recall French pointillism and represent both the literal audience and the worldwide audience of soccer fans. "Soccer is a global sport!" says designer Raffaele Fontanella.

White space remains the poster's focal design element. The white figure and ball, revealed by the seemingly random pattern of dots, create a faceless, almost genderless soccer player who could be any person from any country.

Five colors, the colors of the Olympic rings, create this vibrant poster for the France '98 World Soccer Championship. The brilliant white figure, ball, and text contrast with the bright colors for an exciting image.

Activate.net Sales Kit
Widmeyer Design

art director >	Ken Widmeyer
designers >	Barbara Dunshee, Diana Chang
photographer >	FPG
client >	Activate.net
client's business >	Web broadcasting and streaming
printer >	GAC
paper >	Mohawk Superfine Cover
colors >	Four match plus flood varnish
printing >	Offset
size >	9" x 11 ½" (23 cm x 29 cm) (folder); 8 ½" x 11" (22 cm x 28 cm) (inserts)
print run >	5,000

>> White is a bright accent in this distinctive sales kit, which relies on color and shape for its impact. Ghosted out of the vivid inks, white comes as an intriguing surprise and acts as a fifth ink color.

Precise printing was necessary for this piece's success, which relies on solid ink coverage and exact registration to give it a look so crisp that it might have been screenprinted. An allover varnish adds to the visual depth and smoothness.

The thick white paper stock is printed in such strong colors that, revealed in ghosted letters, it comes as a surprise. Flood silicon varnish adds to the thick, deep colors.

The mostly white business card, stark against the saturated inks, stands out. Strategic white lettering acts as a bright fifth ink color throughout the sales pieces.

art director > Oscar Fernández
designer > M. Christopher Jones
editor > Anne Bremner
photographer > Wexner Center
client > Wexner Center
client's business > Cultural/Arts Center
printer > Ohio State University
paper > Mohawk Superfine, UV Ultra
colors > Four-color process
printing > Offset
size > 8" x 8" (20 cm x 20 cm)
print run > 5,000

>> Both elegant and progressive, this book created to celebrate a cultural center's tenth anniversary uses white to temper and contain profuse, energetic photographs. Color and black-and-white shots of exhibits, performances, stills from films, and portraits paint a vivid picture of a decade of art.

Ink sinks into the matte paper, dampening the images' energy. Classic, mannered use of white space further contains and diffuses the art and text. "The very cover jacket conveys the power of white through the translucent material, causing a wash out," says designer Oscar Fernández. The vellum wrap literally contains the book, as the building contains the performances and exhibits within it.

A translucent vellum wrap obscures the cover photo, a close-up shot of the Wexner Center's distinct architecture. Printed in gray and black, the white cover dulls the color photo so that it looks black and white.

Inside, white contains and diffuses the energetic photography. The inks sink into the bright white matte paper, putting distance between the book and the reader. Extensive use of gray type continues the understated design.

Mahlum Architects Invitation
Michael Courtney Design

art director > Michael Courtney
designers > Michael Courtney, Michelle Rieb
photographer > Latona Productions
client > Mahlum Architects
printer > Evergreen Printing
paper > Various
colors > Three match (book); four-color process (cards)
printing > Offset
size > 6 ¼" x 9" (15.5 cm x 23 cm)
print run > 1,500

>> Designed as a one-of-a-kind invitation to new office space, this invitation had a one-year second life as an introduction to new clients. The wire-bound book uses white paper to contrast with decorative colored pages and to present text, illustrations, and photos on a neutral ground.

Bound-in envelopes contain surprises and add texture. "The book was designed to keep the reader involved and to be memorable," says designer Michael Courtney. "We wanted the book to read as three chapters, broken up with color dividers. We used thick confetti papers to gain color without multiple press runs. White pages tie the story together."

The invitation's strong red cover sets the stage for colored papers used as "chapter" dividers. The story of the client's new offices is told with text and sketches presented on calm white papers. Bound-in envelopes add surprises. A white vellum envelope holds a letter; a black envelope holds color photos of architectural details in the new offices.

The Queen's New Year's Gift
VIA, Inc.

art director > Andreas Kranz
designer > Andreas Kranz
client > Affetti Strumentali
client's business > Musicians
printer > LaGamba
colors > Two
printing > Offset
size > 5 1/2" x 4 3/4" (14 cm x 12 cm)
print run > 5,000

>> This CD cover for an early music ensemble from Germany uses white to balance the two-color palette. On the front cover, the blue and green image floats in white space. On the back and inside front cover, blue and white accent a green ground. The disc itself is screenprinted green, with a blue image and white lettering. It rests against a blue ground. The effect is a three-color job, with each of the colors given equal weight.

White space gives the CD cover a clean, elegant look. The clear jewel case reveals a band of green featuring blue and white lettering.

Inside, the color treatment reverses. Green becomes the dominant color, both on the inside cover and on the CD itself, with white as an accent. Again, the clear jewel case reveals printed paper, a dark blue square creating a frame for the disc.

art director > Vicki Strull
designers > Vicki Strull, Jason Snape
copywriter > Mimi Bean
client > Charlie Eitel
client's business > Consultant
printer > Dickson's Printing
paper > Crane's Crest R
colors > Two
printing > Offset, Engraving
size > Various
print run > Various

>> This identity package for a former CEO and COO turned author and business consultant communicates two distinct but complementary qualities: serious business knowledge and an encouraging, friendly personality. The client's initials tell the whole story. The lower-case C and upper-case E imply formality and informality, tradition and innovation.

Color tells the story, too. A bold combination of white and blue, in which neither color dominates, the color scheme is both corporate and unique.

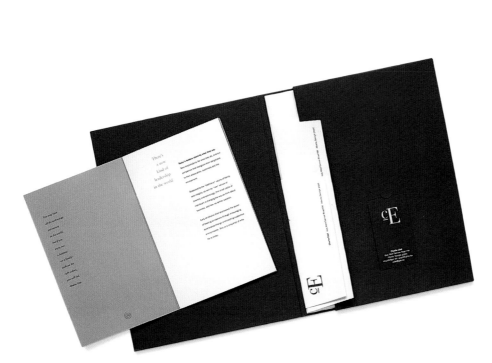

A particularly opaque blue ink makes an equally strong impression on white paper, while a blue business card stands out from typical cards. A matching brochure fits into a pocket in the folder. Here a new ink color, greenish brown, becomes a neutral foil for blue and white.

Opaque white ink on deep, matte blue paper stock makes an immediate strong impression for this letterhead and marketing package.

fraduo...
is the economical C1S alternative to more
costly bleached sulphite board.

Up to 70% recycled content
Treatments for grease/water resistance
Available with tinted back liner
Excellent printability and convertability

Economical

fra/ast...
is a highly functional C1S alternative
to CCNB.

Up to 80% recycled content
Treatments for grease/water resistance
Wide range of applications
Good printability and convertability

Highly functional

white in three dimensions

>>The ancient Greeks didn't build white buildings. They painted their temples, houses, marketplaces, and statues in bright colors and covered them with intricate designs. Centuries have worn away that color, leaving the white skeletons we love today. Perhaps the ancient Greeks wouldn't find the all-white architectural palette an improvement, but the haunting ruins of ancient Greece demonstrate the power of white in three dimensions.

For more than a decade, interior designers have favored white for kitchens and other hard-to-clean rooms, demonstrating the triumph of ideal over practicality. For nearly a hundred years, white satin has been nearly mandatory for brides in the West—the color denoting purity, the costly and easily stained fabric emphasizing that the event is more important than everyday concerns.

Children love the softness (and blandness) of white bread. Fred Astaire broke hearts in his white tie and tails. White sands, white clouds, white snow, and white stars have inspired poets and artists since time began. White is the color of ghosts, of shrouds, of lace, of ermine. From the buildings and rooms we live in to the clothes we wear and objects we use, white is a color of endless possibilities.

art director > Jennifer Sterling
designer > Jennifer Sterling
illustrator > Jennifer Sterling
lettering > Jennifer Sterling
photographer > Marko Lavrisha
copywriter > Eric LaBrecque
clients > Marko Lavrisha and
Eric LaBrecque
client's business > Photography and writing
printer > H. MacDonald Printing/Color Bar
size > 6 ¹/₄" x 8 ⁷/₈" (15.5 cm x 22 cm)

>> A set of enigmatic printed papers mailed in a velvet-covered
slipcase promote a photographer and a writer. Each thick white paper is printed
on one side with a photograph—on the other, with text arranged so that the
meaning of the words is secondary to their design. The heavy, bright paper sets off
both the photos and the type, making the work seem both important and full of
hidden meaning.

The velvet-covered slipcase holds an unusual promo for a photographer and a writer. The white cover, with faded black ink stamped into the velvet, gives no hint about what's inside. Recipients pull on the black ribbon to release the sheaf of papers.

A series of stiff white cards, each printed
with a photo on one side and an unusual
arrangement of text on the other, presents
the work of both clients. White space
frames the photos conventionally. The
text, however, becomes as much an
abstract design as a caption or commen-
tary, often squeezed into a tiny bar at
the bottom of the white page or arranged
in an elaborate diagram.

4

5

IS IT
POSSIBLE
THAT,
TO REDISCOVER
THEIR USES,
CIVILIZATION
AS WE
KNOW IT MUST
COME TO
AN END?
LESSON 5

6

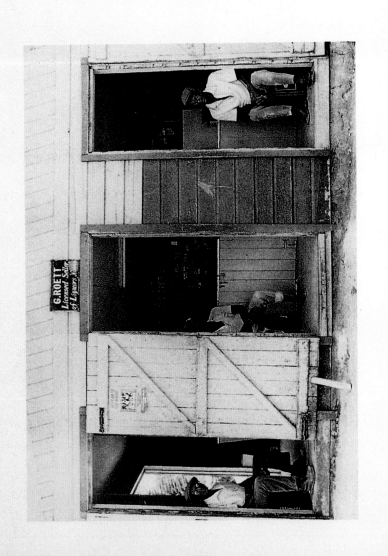

YOU WOULD THINK AN
ISLAND WOULD CATCH
HISTORY THE WAY IT
CATCHES DRIFTWOOD,
BUT IT IS NOT THAT
WAY, HISTORY IS MORE
LIKE THE BIRDS THAT
HAVE ALMOST VANISHED,
IT SURVIVES ON POOLS
AND POCKETS, IN OUT-OF
-THE-WAY CORNERS WHER
THE RESORTS GO UP THE
PRESENT CROWDS IT OU
MAYBE IT LIVES ON AS
THEME ON THE WALLPAP
I DONT KNOW I DON'T
KNOW I KNOW DON'T K
KNOW I KNOW I KNOW I
I KNOW I KNOW NO NO
NO NO NO NO NO NO NO

The text coordinates with the facing photo
but doesn't tell a straightforward story.
The result is a series of unrelated photo
essays that hint at more than they say.

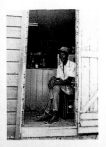

THERE IS NO SLAVERY,
BUT THERE IS NO
BROTHERHOOD EITHER
THERE IS NO SLAVERY,
BUT THERE IS NO
BROTHERHOOD EITHER
BUT THERE IS NO SLAVERY,
BUT THERE IS NO BROTHERHOOD EITHER
THERE THERE IS NO SLAVERY,
THERE IS NO SLAVERY,
BUT THERE IS NO
BROTHERHOOD EITHER THERE IS NO

THERE IS NO SLAVERY,
BUT THERE IS NO
BROTHERHOOD EITHER
THERE IS NO SLAVERY,
BUT THERE IS NO
BROTHERHOOD EITHER
BUT THERE IS NO SLAVERY,
BUT THERE IS NO BROTHERHOOD EITHER
THERE THERE IS NO SLAVERY,
THERE IS NO SLAVERY,
BUT THERE IS NO
BROTHERHOOD EITHER THERE IS NO

BROTHERHOOD EITHER
THERE IS NO SLAVERY,
BUT THERE IS NO SLAVERY,
BROTHERHOOD EITHER
BROTHERHOOD EITHER

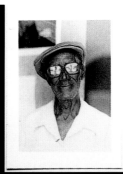

WE BECAME FREE THE DAY
OTHERS COULD AFFORD TO
IGNORE US.
WE BECAME FREE THE DAY OTHERS
COULD AFFORD TO
WE BECAME FREE THE DAY
OTHERS COULD AFFORD TO
IGNORE US.
WE BECAME FREE THE DAY OTHERS COULD
COULD AFFORD TO WE BECAME FREE THE DAY
OTHERS COULD WE BECAME FREE THE DAY
BECAME US. WE BECAME FREE THE DAY
OTHERS COULD AFFORD TO WE BECAME FRE
WE BECAME FREE THE DAY

Ted Gordon CD-ROM
Pensaré Design

art director > Mary Ellen Vehlow
designer > Kundia D. Beverly
illustrator > Ted Gordon
copywriters > Roger Cardinal, Mary Ellen Vehlow
client > Roots and Wings
client's business > Nonprofit foundation

>> Part of a project to increase the visibility of self-taught American folk artists, this CD-ROM introduces a "man addicted to doodling," Ted Gordon. The all-white CD and case set the stage for a rarity in computer graphics: black and white imagery. Black and white images, movies (colored, but muted), and gray text glide on and off the "pages," narrated by a woman's calm voice.

Gordon's intense sketches are perfectly suited to this restful treatment. His thick black lines cover nearly every surface of his paper. Presenting them on a white surface gives them context and contrast. Carrying the emphasis on white throughout the presentation creates a peaceful environment for a complex man and his turbulent work.

No printed cover hides the white CD-ROM, resting calmly in its white plastic case. The tagline, "a very ordinary man," clues the user that the CD's subject is far from ordinary.

The artist and his black-and-white drawings are presented simply on all-white pages. Throughout the presentation, abundant white space showcases the intense artwork and subdued type and photographs, creating an overall calm feeling.

White Cottage Wine Label
Auston Design Group

art director > Tony Auston
designer > Tony Auston
photographer > David Bishop
client > Howell Mountain White Cottage
client's business > Winery
printer > Herdel Printing
paper > Gainsborough
colors > Two
printing > Hot-stamping
size > 4" x 3 ¹/₂" (10 cm x 9 cm)

>> The designer's challenge was to design a label that would brand the Napa Valley wine as hand-crafted by a small producer. A deckle-edged label in a heavy white paper with a hand-made look, created with specialty printing techniques, was the answer. Two pigment foils hot-stamped onto the paper provide distinctive type. Blind debossing flattens the paper's texture, creating two "panels" of information.

Finishing the labels is a family affair. "The deckle edge is achieved by hand-tearing each label," says designer Tony Auston. "This process is the duty of the winemaker's children."

Distinctive and hand-produced, this wine label gets its impact from its distinctive, textured white paper. A deckle edge (produced by the winemaker's children), foil-stamping, and debossing all add further texture to the graphics.

Zona O Set
ONCE TV

art director > Edgar del Castillo Vilchis
designer > Edgar del Castillo Vilchis
photographer > Carlos Alberto Leal
client > ONCE TV
client's business > Television production

>>Design for children is frequently large, bright, and crowded. This set for a Mexican children's television program, Zona O, is no exception, but the bold use of white presents and ties together a host of other colors.

The all-white main set, with its black bull's eye on the floor, looks bigger than it is because it's difficult for the eye to judge size without a familiar context. Circular holes cut in the curving wall provide windows to other small, colored sets, acting as frames for the hosts and providing a neutral foreground.

The main set connects to smaller, colored sets, contrasting with and framing them, and giving them greater visual impact.

The abstract set creates many opportunities for fun camera angles and optical illusions. White also emphasizes the hosts' colorful clothes.

Delta 757 *Soaring Spirit*
Copeland Hirthler design + communications

art director > Brad Copeland
designer > Mike Weikert
client > Delta Air Lines
painter > Boeing

>> Airplanes produce an unequaled opportunity for supergraphics. To demonstrate its support for the 2002 Olympic Winter Games, Delta Air Lines wanted a design that included its corporate colors and the Olympic rings symbol (restricted to official sponsors).

"White was the dominant color in this design," says designer Mike Weikert. "It served as a clean canvas for the bold, bright colors of the graphics and logos, and so became the perfect backdrop for the aircraft's branding."

This design for airplane graphics shows the status of Delta Air Lines as an official sponsor of the 2002 Olympic Winter Games. Like most airplane design, it is mainly white. Here white sets off the design's bright colors and symbolizes snow.

Box Bored?
VIA, Inc.

art director > Oscar Fernández
designer > Oscar Fernández
copywriter > Wendie Wulff
client > Fraser Paper
client's business > Paper Manufacturer
printer > GAC, Indianapolis
paper > Fraser bleached board
colors > Six
printing > Offset
size > 9 ½" x 6 ½" x 3 ½"
(24 cm x 17 cm x 9 cm)
print run > 25,000

>> This package introducing Fraser Papers, from Canada, to a U.S. audience drew a phenomenal 40% response rate. Mailed in a white box printed with teaser copy ("Box Bored?"), the samples of box-weight papers were not sent as cards but as tiny boxes.

Viewed from the top, the six tiny boxes inside are also white, but once removed from the holder, they reveal their secret. Each side of the cardboard cube is printed in a different color, with part of a different message. Like block puzzles for children, the boxes can be rearranged to form six different images.

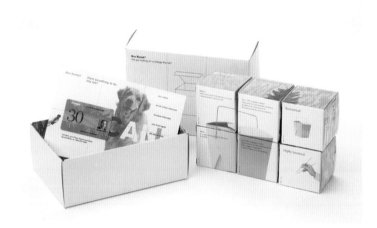

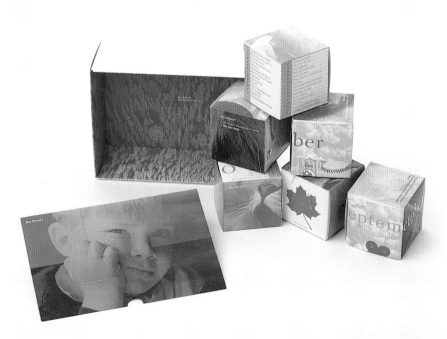

Mailed in a white box, with a primarily white explanatory card, the small boxes inside have a spare black and white look that communicates simple facts about the paper company and its products. But they are only part of the story.

Turn the mailing card over and find a colorful surprise—one echoed by the other five sides of each small cube. The boxes can be rearranged to show five other, colored images and advertising messages. Throughout, white is used as an attractive accent to the muted colors and natural images that communicate the paper board's high recycled content.

Origami Paper Promotion
Estudio Pérez Medina

art director > David Pérez Medina
designer > David Pérez Medina
illustrators > David Pérez Medina, Oscar Saez
photographer > Manuel Lopez Escribano
copywriter > David Pérez Medina
origami figure > Robert Harbin
client > Tom·s Redondo
client's business > Paper merchant
printer > Torreangulo
paper > Tom's Redondo
colors > Two
printing > Offset
size > 6 ¹/₈" x 6 ¹/₄" (15 cm x 16 cm)
print run > 10,000

>> This neat package for a paper merchant is a combination Christmas gift/paper brochure. The subtle vellum paper displayed inside inspired the Japanese simplicity of its design.

A folded case made of heavy grooved paper, its cover custom die cut with the shape of an origami Christmas tree, provides the first subtle holiday greeting. White paper and silver printing beneath the die-cut shape communicate an elegant Christmas feel without words. Inside, detailed instructions on how to fold the trees top a selection of vellum and tissue papers, most of them white and suitable for origami. A delicate handwriting typeface, printed in silver ink, identifies each paper.

An envelope made of transparent silver vellum completes the package. Recipients can see through it to the die cut shape, making them curious about what lies inside.

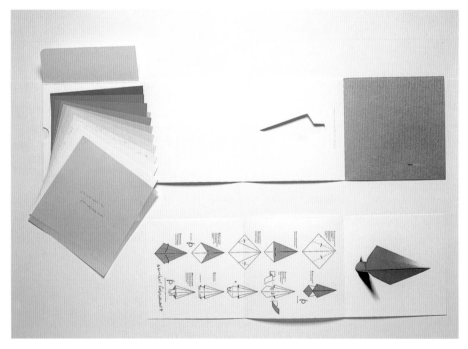

This paper promotion/Christmas gift came wrapped in a silver vellum envelope. Recipients caught an intriguing glimpse of the white and silver package within.

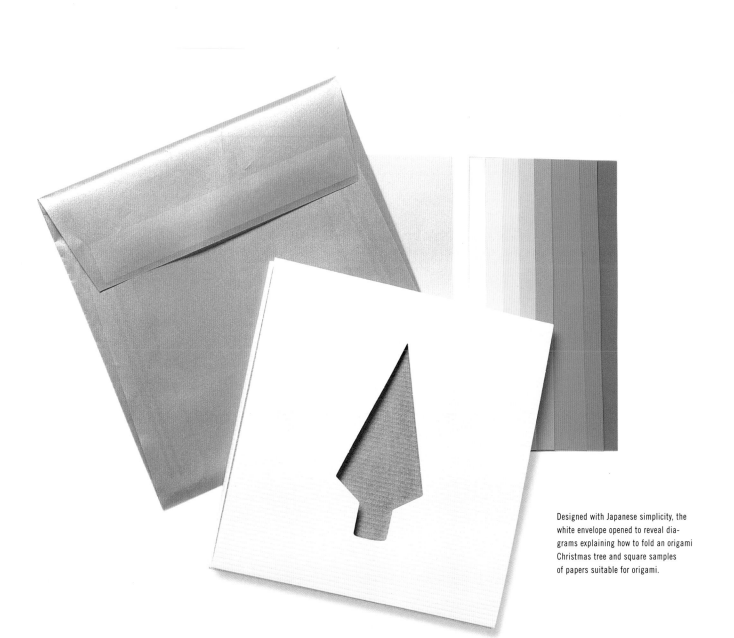

Designed with Japanese simplicity, the white envelope opened to reveal diagrams explaining how to fold an origami Christmas tree and square samples of papers suitable for origami.

Extra-Strength Peppermint Packaging
David Lemley Design

art director > David Lemley
designer > David Lemley
client > Brown and Haley
client's business > Candy makers
printer > Yu Yin Can Ltd.
material > Tin
colors > Four match
printing > Offset
print run > 50,000

>> The tin containers for this "alternative Altoids" candy are mostly white, to symbolize their fresh taste. But while their competitor uses old-fashioned design, this candy is as contemporary as it comes. Wild type and cartoon drawings help communicate the "extra strength" message.

The cardboard display unit for this peppermint candy uses the same graphics found on its tin containers. White symbolizes freshness, and acts as a canvas for the flamboyant type. The cartoon face breathes a flame—or is it an "extra-strength" mint leaf?

Lingo Installation Kit
David Lemley Design

art director > David Lemley
designers > David Lemley, Tawnya Lemley
client > Active Voice
client's business > Telephone/computer services
printer > Tharco Container Co.
substrates > Cardboard, metal, label stock
colors > Three match
printing > Screenprinting
size > 12" x 28" x 20"
(30 cm x 71 cm x 51 cm)
print run > 500

>>The retro packaging for this voice-mail promotion uses white cardboard to showcase the surprise contents: a white screwdriver. Deliberately off - register, the design's hip, done-on-the cheap look belies its artful construction. A product of the no-bleed design, says David Lemley, "the white space creates the desired retro feel. Screenprinting gave the colors a nice flatness, which helps give the cardboard the illusion of being nice paper." The humorous instructions inside the box were printed on white label stock, which was affixed to the box before cutting and construction.

The white cardboard boxes become a design focus in this packing for a voice-mail company's promotion. Screenprinted inks provide a hip, retro look and harmonize with the flat white cardboard. Inside, a red cardboard base showcases the humorous gift, a white screwdriver.

Park Hyatt Tokyo Wedding and
Banqueting Sales Kit
David Carter Design Associates

art director > Sharon LeJeune
designer > Sharon LeJeune
photographer > Stuart Cohen
copywriter > Melissa Gatchel North
client > Park Hyatt Tokyo
client's business > Hotel
printer > Heritage Press
paper > Starwhite Vicksburg
colors > Six
printing > Offset, plus engraving and embossing
size > 10" x 10" (25 cm x 25 cm)
print run > 10,000

>>Though this elegant package is all Japanese in design aesthetics, the extensive photographs used throughout the pieces show only Westerners. The hotel wanted an exotic Western look to appeal to wealthy Japanese families looking for Western-style wedding services.

True to Japanese expectations, the numerous pieces in this promotion nestle together in one beautiful, neat presentation that would not be typical of similar materials in the West. White, the color of weddings in the West, gives the package an appropriate context. It also shows off the fine papers, printing, and engraving used for this piece, which advertises premium services at a luxury hotel.

Wedding-style embossing and engraving add a luxurious touch to this elegant package of all-white pieces.

Booklets, boxes, and envelopes nestle together in Japanese fashion, tied together with white ribbon in a classic Japanese bookbinding technique.

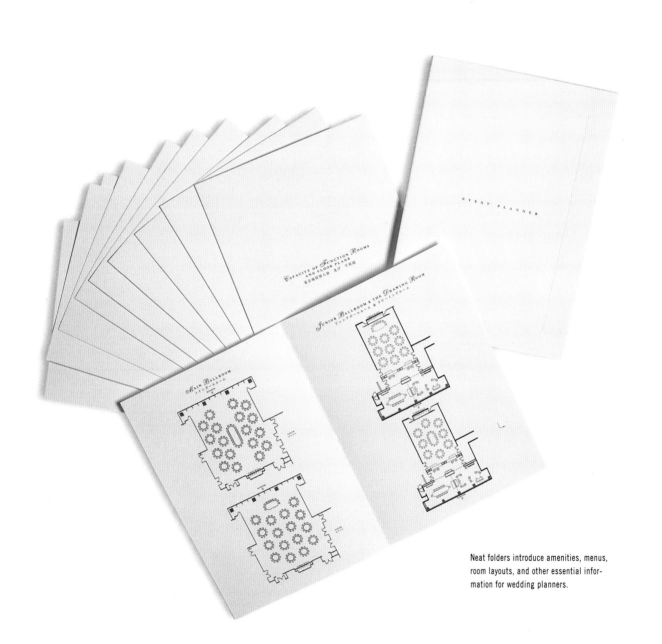

Neat folders introduce amenities, menus, room layouts, and other essential information for wedding planners.

Very different in design, this booklet introducing the hotel is included in the box—but in a white envelope, of course.

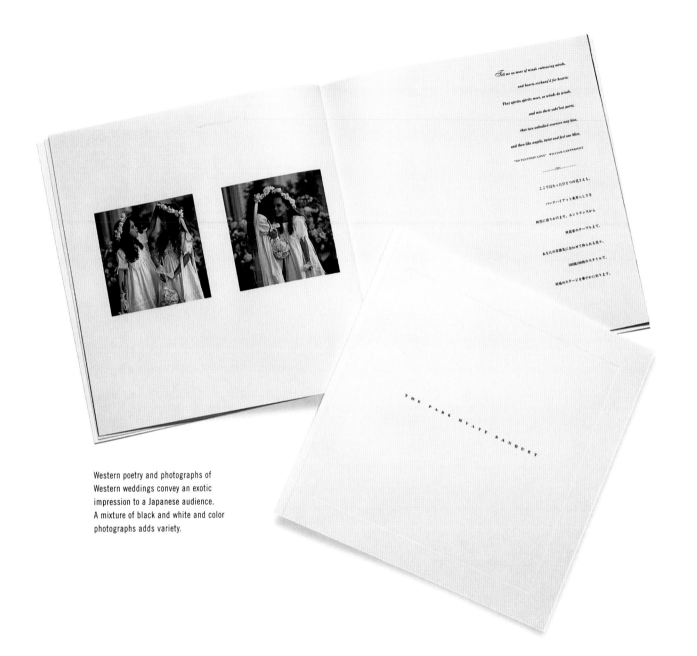

Western poetry and photographs of
Western weddings convey an exotic
impression to a Japanese audience.
A mixture of black and white and color
photographs adds variety.

Art of Communication
The Riordon Design Group, Inc.

art director > Ric Riordon
designers > Dan Wheaton, Shirley Riordon, Ric Riordon
photoshop enhancement > Dan Wheaton, Blake Morrow
photographers > Steve Grimes, David White
copywriters > Ric Riordon, Shirley Riordon
client > Self
printer > Somerset Graphics
binding > Anstey Bookbinding
paper > Potlatch Utopia
colors > Four-color process plus metallic ink and varnishes
printing > Stochastic
size > 8" x 13" (20 cm x 33 cm)
print run > 1,500

>> This colorful self-promotion uses white space to tone down what might be, otherwise, a little too energetic and dynamic. Covered with two textured, metallic silver papers, the three-ring binder is lined with purple velvet paper for a sumptuous look. It holds die-cut, full-color pages displaying the company's work to potential clients.

Silver ink and glossy varnish on the project pages continue the look begun on the cover. Each project is displayed on a pure white page in several cut-out shots. Digitally produced shadows give the photos a three-dimensional look. The white pages tone down the saturated color, grounding the projects and tying them together.

A looseleaf binder with a printed metallic cover looks lavish but is deceptively low-key. Inside the silver covers, the self-promotion explodes with color.

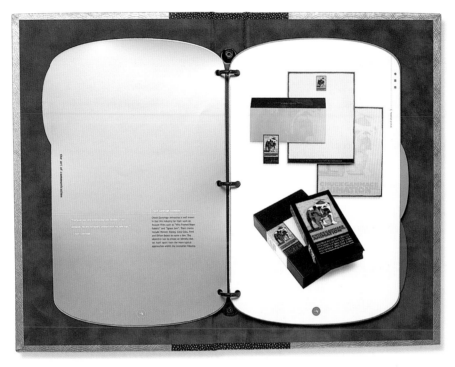

Purple velvet paper lines the binder for a royal look. Tabbed dividers in bright colors introduce each section. White space and computer-created shadows anchor the colorful project photos. Each white project page faces a silver page, continuing the silver theme and further contrasting with the bright colors.

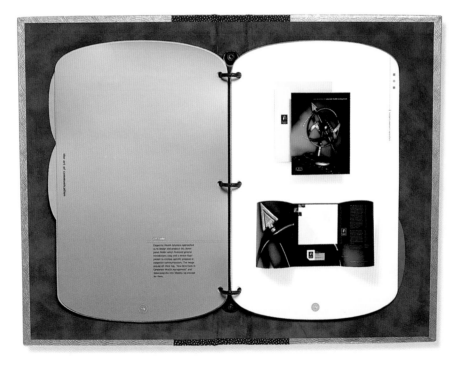

BHOSS CD
Sterling Design

art director > Jennifer Sterling
designer > Jennifer Sterling
illustrator > Jennifer Sterling
lettering > Jennifer Sterling
client > Wyndham Hill
client's business > Music producers
printing > Letterpress

>> Wyndham Hill wanted a design for a new CD by the Braxton Brothers that would help it get air time from jazz stations around North America. Designed to intrigue DJs, who receive dozens of promo CDs every week, this provocative package included a cut-metal cover, a stack of die cut paper disks — and, of course, the CD itself. While the printed disks each had a different look, they shared a common design sensibility. Extensive white space showcased both the designs and the deep embossing.

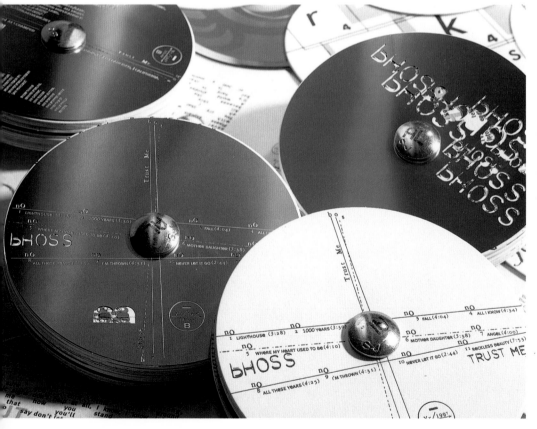

Using graphics and lots of thick white paper, the designer created a memorable promotion package for a new jazz CD. Mysterious diagrams and images, cut-metal plates, and, of course, the CD itself (printed red) made a combination disk jockeys couldn't resist. Letterpress printing adds to the distinctive look of the piece.

1 song

WALKING TO THE LIGHTHOUSE,
THAT MOMENT WHEN I KNEW
I'D FALLEN IN LOVE AGAIN.
QUIETLY WE STOOD IN AWE,
THE RAGING SEA, OF YOU AND ME
STORM CLOUDS GATHERED RAIN

YOU SAID "WON'T YOU LOOK AT ME WITH BOTH EYES OPEN W...I...D...E ? WHAT'S YOUR HURRY - CAN'T YOU JUST ENJOY THE RIDE?"

QUESTIONS KEEP COMING LIKE WAVES ON THE SHORE.

ALL OUR LIVES ARE SPENT ON WORDS WE LEAVE BEHIND.
TIME, TIME, TIME.
NEVER A REASON OR RHYME.
ANSWERS JUST ROLL ON BY.
LOVE IS LOST, AND FOUND AGAIN.
BREATHING DEEP, I HOLD YOU IN -
BUT THE PAIN RECEDES SO SLOW.
COME TO ME, TAKE MY HAND.
LET ME GO, I DON'T UNDERSTAND.
WHERE DO ALL THOSE FEELINGS GO?
YOU SAID THAT YOU NEVER,
EVER
TRIED TO LEAD ME ON.
IT WAS CLEAR I LOVED YOU FOR THE REASONS THAT WERE WRONG.
I WOULD BET THE MINUTE LOVE IS SAID, YOU'RE GONE.
DON'T LOOK AT ME LIKE YOU DON'T KNOW ME.
SPARE ME YOUR MISGUIDED PITY.
I SHOULD LISTEN TO MY FRIENDS MORE.
WAS
THIS JUST A WASTE
OF
TIME?

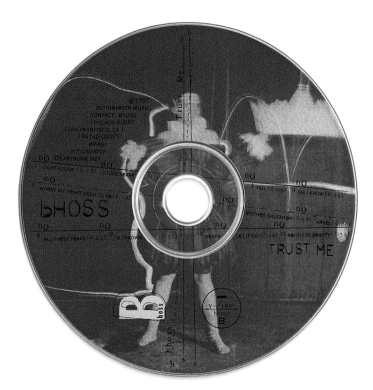

Winter Holiday Card
Michael Stanard, Inc.

art director > Michael Stanard
designer > Michael Stanard
illustrator > Michael Stanard
client > Self
printer > Ace Graphics
paper > Krome Kote
colors > None
printing > Die-cut
size > 6" (15 cm)
print run > 5,000

>>Talk about getting your money's worth from a die . . . designer Michael Stanard may have set the record. He designed this card twenty-two years ago and has been sending it ever since.

The circular card, which folds into a three-dimensional ornament, is not specific to any holiday or faith. The white dove symbolizing peace is equally at home on a Christmas tree and adorning an office cubicle. A small rectangular card, produced in-house on a laser printer and tied to the ribbon holder, identifies the giver.

Appropriate for all faiths, this winter card features a die-cut dove symbolizing peace. It folds into a three-dimensional ornament.

Meridian Business Park Sculpture
Lorenc + Yoo Design

art director > Jan Lorenc
designer > Jan Lorenc
photographer > Jan Lorenc Design

>> Surrounded by lush plantings, a phalanx of abstract white sculptures seems to sprout from the ground at this entrance to a business park. They announce the park's boundaries with more drama than a simple planting and look far more welcoming than a fence or wall. They can be enjoyed equally by workers and by people passing by. And because the sculptures' angled white faces reflect the sun and the clouds, they look different throughout the day.

Light and shadow play constantly on the angled faces of the sculptures and wind shifts the grass and flowers planted at their feet for an ever-changing view.

2000 Calendar
AERIAL

art director > Tracy Moon
designer > Tracy Moon
client > Self
printer > Visual Identity Design Digital Engraving
paper > Somerset 100% Cotton Rag
colors > One (overleaf); none (pages)
printing > Blind Emboss
size > 4 5/8" x 5 3/8" (11.5 cm x 14 cm)
print run > 600

>> To challenge assumptions about graphic design—including the assumption that it can be seen—the design firm mailed an all-white calendar to its clients as a gift to celebrate the year 2000. "I decided to do something I had always wanted to do," says art director Tracy Moon. "Produce a piece that was entirely about form, devoid of function. Merely there to delight."

With blind-embossed copy and die-cut scalloped edges, the ever-functional calendar became a literal blank slate. It can be read, but only when light hits it at a 30° angle—which AERIAL admits makes it more of a sundial than a calendar. "The goal was to communicate a message with the absence of visual stimuli, rather than the opposite," Moon explains. "With all of the clutter created and received in our lives every day, this piece was intended as a deliberate visual respite. It says, 'Less really is more.'"

Colored vellum sheets separate the all-white pages. An explanation, printed in white ink on lavender vellum, invites users to relax and live rather than manage every moment.

Each page was created digitally, then made into a copper die. Pages include text in English, French, German, Spanish, Italian, Chinese—and, of course, Braille lettering.

Set on a clear plastic easel, the nearly unreadable calendar is a three-dimensional example of how the design company that sent it looks at things with a fresh eye.

art director > Teresa M. Carbon
designer > Teresa M. Carbon
illustrator > Jeff Nishinaka
client > *Business Travel News*
client's business > Trade magazine
colors > Four-color process
printing > Offset
size > 8 ¼" x 10 ¾" (20 cm x 27 cm)

>> An all-white paper collage provided an intriguing cover and low-cost design solution for this trade magazine aimed at the business travel industry. Art director Teresa Carbon found a series of paper collages on a clip-art CD and combined them digitally for this custom, all-white illustration.

"The topic of automation is most often illustrated by a barrage of bright colors and busy images," Carbon says. "This solution clearly indicates the subject matter while presenting a cool, modern integrity with the white palette. The $300 cost of the CD was the only expense."

The trade magazine's art director combined several paper collages offered on a clip-art CD into one custom illustration. She duplicated the paper's surface pattern for the blue type and added shadows to match the three-dimensional illustration. The resulting all-white cover gives this annual "Automation" special a distinctive look.

Workbooks
Hesse Designstudios GmbH

art director > Klaus Hesse
designers > Various
illustrators > Various
photographers > Various
client > Self
size > 8 ³/₈" x 12" (21 cm x 30 cm)

>> Since 1993, the designers at this German studio have given clients a blank "workbook" for the holidays. Each is filled with thick white pages, the designers say, "for scribbles, dreams, ideas, meetings, or even the drawings of their kids."

The covers are where the studio can show off design skills and suggest creativity. But the books themselves provide clients with the gift of white space—the irresistible chance to explore their own creativity, to put their own words and images on a beautiful and inviting book made just for them.

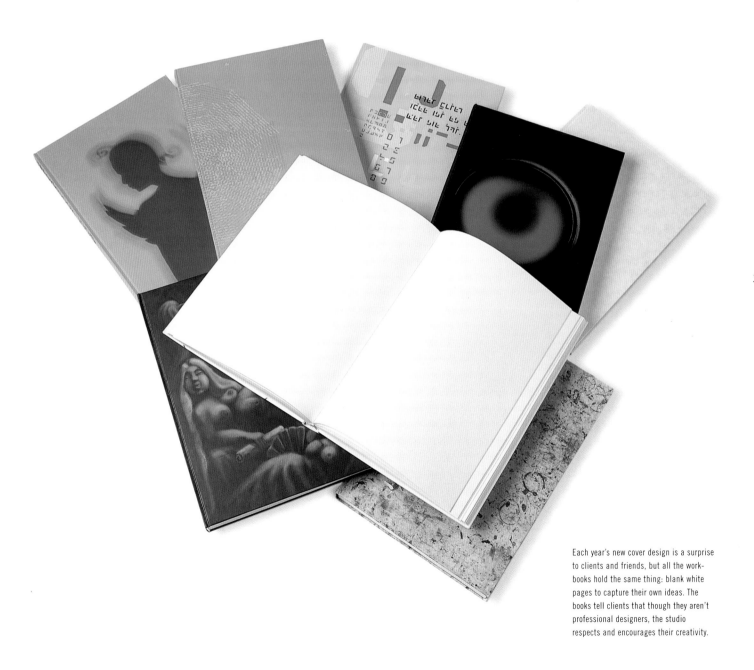

Each year's new cover design is a surprise to clients and friends, but all the workbooks hold the same thing: blank white pages to capture their own ideas. The books tell clients that though they aren't professional designers, the studio respects and encourages their creativity.

San Francisco Museum of Modern Art
Invitation and Program
Sterling Design

art director > Jennifer Sterling
designer > Jennifer Sterling
illustrator > Jennifer Sterling
client > San Francisco Museum of Modern Art
printer > H. MacDonald
colors > Three match
printing > Offset
size > 4 ¹/₂" x 6" (11 cm x 15 cm) (invitation); 5 ¹/₂" x 8 ¹/₂" (14 cm x 22 cm) (program)

>> This set of matching pieces for an exhibit at the San Francisco Museum of Modern Art is as tactile as it is graphic. Heavy white pages make a big impression with custom die-cut edges and numbers. An unusual arrangement of type, both classic and modern, gives the pieces an elegant look and communicates a lot of information without overwhelming the reader.

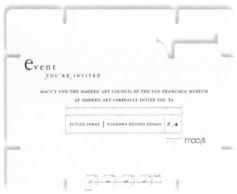

The invitation, mailed in a white vellum envelope, consists of four two-sided cards. Large numbers die-cut into the cards let readers know what order to read them in. A yellow vellum envelope marks the invitation's response card.

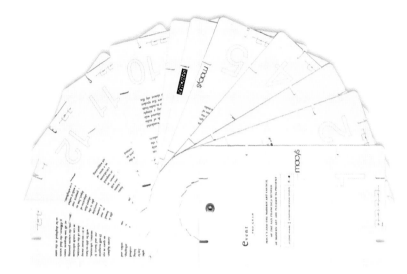

P r o g r a m

patrons*

Dione Bowers

Sandra Brown

James Cushing, Chairman, Next Generation Cities

Diana Dalton

Noel and Lloyd Hanford

Allen A. Hitchcock

Robert and Ann Hunter

Kathryn and William Keller

Dorothy Knecht

Rica Lakamp

Elaine McKeon

Ellen and Walter Newman

Dr. Fredric J. Philips

Elizabeth Spencer Pfau

Linda Zweig

sponsors

MACY'S

SAN FRANCISCO MUSEUM OF MODERN ART

ARCHITECTURE AND DESIGN FORUM

ROBERT MONDAVI WINERY

PEBBLE BEACH RESORTS

CASA PALMERO

THE SPA AT PEBBLE BEACH

SPYGLASS HILL GOLF COURSE

EVENT CHAIRS

Michael Steinberg

Dione Bowers

Eve Masonek

08 | 04 | 1999

FUTURE FORMS | WINDOWS BEYOND DESIGN

* Listing as of 7/28/99. | We apologize for the inadvertent omission of any names.

< Special thanks to: Robert Brunner | Federico De Vera | Daven Joy | Pablo Pardo | Michael Vanderbyl >

The program design follows the invitation specs, but at a larger scale. A white vellum envelope holds the text-heavy catalog, its pages held together by a metal screw fastener. The die cut pages include plenty of plain white, organizing and highlighting the information.

> directory

5D Studio
20651 Seaboard Road
Malibu, CA 90265
310-317-0705

AERIAL
58 Federal St.
San Francisco, CA 94107-1422
415-957-9761

abo-konzepte mit Kunst
Am Overfeld 9
D-83 104 Hohenthann
Germany
08065 180590

Arrowstreet Graphic Design
212 Elm Street
Somerville, MA 02144
617-623-5555

Auston Design Group
651 Main Street
Saint Helena, CA 94574-2004
707-963-4152

Becker Design
225 East St. Paul Ave.
Suite 300
Milwaukee, WI 53202
414-224-4942

Belyea
1007 Tower Building
1809 Seventh Avenue
Seattle, WA 98101
206-682-4895

Blok Design
398 Adelaide St.
Suite 602
Toronto, ON M5V 2K4
Canada
416-203-0187

Henrick Bo grafisk design
Tværvej 3
2960 Rungsted Kyst
Denmark
+ 45 45 57 0870

Buero fuer Gestaltung
Domstrasse 81
D-63067 Offenbach
49 69 88 14 24

Business Travel News
One Penn Plaza
10th Floor
New York, NY 10119
212-615-2254

David Carter Design Associates
4112 Swiss Avenue
Dallas, TX 75204
214-826-4631

Copeland Hirthler design + communications
40 Inwood Circle
Atlanta, GA 30309
404-892-3472

Michael Courtney Design
121 East Boston
Seattle, WA 98102
206-329-8188

Estudio Pérez Medina
La Peñota, 18
28002 Madrid
Spain
+34 91 413 55 00

Philip Fass
1310 State Street
Cedar Falls, IA 50613-4128
319-277-6120

Greenfield/Belser
1818 N. Street NW
Suite 110
Washington, DC 20036
202-775-0333

The Heibing Group
315 Wisconsin Avenue
Madison, WI 5703
608-256-6357

Hesse Designstudios GmbH
Rosmarinstrasse 12k
D-40235 Düsseldorf
02 11 23 20 66

Hoffmann & Angelic Design
317-1675 Martin Drive
White Rock, BC V4A 6E2
Canada
604-535-8551

Hornall Anderson Design Works
1008 Western Avenue
Suite 600
Seattle, WA 98104
206-467-5800

HOW Magazine
1507 Dana Avenue
Cincinnati, OH 45207
513-531-2690

KCOP-TV
357 South Curson #6B
Los Angeles, CA 90036
323-935-4053

KINETIK Communication Graphics, Inc.
1604 Seventeenth Street NW
Second Floor
Washington, DC 20009
202-797-0605

Kolar Design
308 East 8th Street
Cincinnati, Ohio 45202
513-241-4884

David Lemley Design
8 Boston Street, #11
Seattle, WA 98109
206-285-6906

Liska + Associates
562 West 26th Street
Suite 7B
New York, NY 10001-5517
212-627-3200

Lorenc + Yoo Design
109 Vickery Street
Roswell, GA 30075
770-645-2828

João Machado Design, Lda
Rua Padre Xavier Coutinho
No. 125
4150-751 Porto
Portugal
351 22 6102772
351 22 6103778

Metropolis
61 West 23rd Street
New York, NY 10010
212-627-9977

The Observer
119 Farringdon Road
London EC1R 3ER
United Kingdom
44 20 7713 4212

Douglas Oliver Design
2054 Broadway
Santa Monica, CA 90404
310-453-3523

Oliver Kuhlmann
168 N. Meramec, Suite 105
St. Louis, MO 63105
314-725-6616

Once TV
Calle 25
107 Col. San Pedro de los Pinos
Mexico D.F. 03800

Ortega Design Studio
1735 Spring Street
St. Helena, Napa Valley, CA 94574
707-963-3539

Michael Osborne Design
444 DeHaro St., Suite 207
San Francisco, CA 94107
415-255-0125

Pensaré Design
729 15th Street NW
Washington, DC 20005
202-638-7700

Pentagram Design Inc.
387 Tehama St.
San Francisco, CA 94103
415-896-0499

R & M Associati Grafici
via del pescatore 3
80053 Castellammare di Stubia
(Napoli)
Italy

Richard Puder Design
2 West Blackwell Street
Dover, NJ 07801-3917
973-361-1310

Qually & Company, Inc.
2238 Central St.
Evanston, IL 60201
847-864-6316

Refinery Design Co.
2001 Alta Vista Street
Dubuque, Iowa 52001-4339
319-584-0172

The Riordon Design Group Inc.
131 George Street
Oakville, Ontario L6J 1E2
Canada
905-339-0750

Chris Rooney Illustration/Design
639 Castro Street
San Francisco, CA 94114-2506
415-865-0303

Sage
4068 Vinings Mill Trail
Smyrna, GA 30080
770-431-8500

Sagmeister Inc.
222 W. 14th St.
Apartment 15A
New York, NY 10011-7226

Sayles Graphic Design
3701 Beaver Avenue
Des Moines, Iowa 50310
515-279-2922

Spur
3504 Ash Street
Baltimore, MD 21211
410-235-7803

Michael Stanard, Inc.
1000 Main
Evanston, IL 60202
847-869-9820

Jennifer Sterling Design
5 Lucerne Suite 4
San Francisco, CA 94103
415-621-3481

StudioWorks
838 Broadway
New York, NY 10003-4812
212-674-028

Tharp Did It
50 University Avenue
Suite 21
Los Gatos, CA 95030
408-354-6726

Tin Design
11 Blackstone Street
Cambridge, MA 02139
617-868-2865

Uppercase Books, Inc.
230 W. Huron, 4th Floor
Chicago, IL 60610
312-280-3232

Vestígio
Rua Chaby Pinheiro
191-2° Andar
P-4460-278 Sra. da Hora
Portugal
+35122 9542461

VIA Inc.
582 East Rich Street
Columbus, Ohio 43215
614-628-8170

VSA Partners
1347 S. State Street
Chicago, IL 60605
312-895-5090

Walker Thomas Associates
The Osment Building
Maples Lane
Prahran, VIC 3181
Australia
+61 39 521 4433

Weaver Design
2157 Vestridge Drive
Birmingham, AL 35216-3340

Widmeyer Design
911 Western Avenue #523
Seattle, WA 98104
206-343-7170

Wooly Pear
126 Bedford Ave., Apt. 2
Brooklyn, NY 11211
718-218-9760

> index